The Sweet Smell of
Home

LEONARD F. CHANA, SUSAN LOBO, AND BARBARA CHANA

With forewords by Rebecca J. Dobkins and Angelo Joaquin Jr.

The Sweet Smell of

Home

The Life and Art of Leonard F. Chana

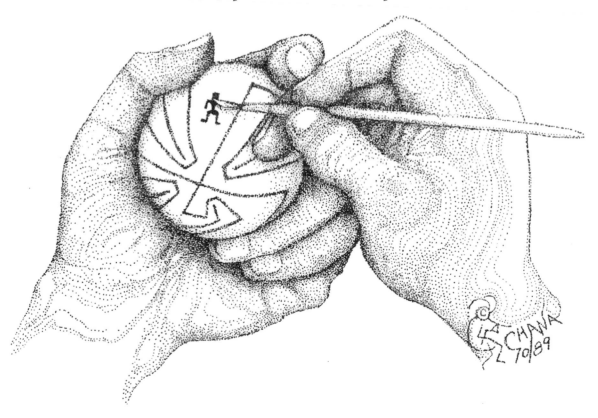

THE UNIVERSITY OF ARIZONA PRESS : TUCSON

The University of Arizona Press

www.uapress.arizona.edu

FRONTISPIECE: *Art* by Leonard F. Chana.

NOTE: All images by Leonard F. Chana unless specified otherwise.

Library of Congress Cataloging-in-Publication Data

Chana, Leonard F.

The sweet smell of home : the life and art of

Leonard F. Chana / Leonard F. Chana, Susan Lobo,

and Barbara Chana ; with forewords by Rebecca J.

Dobkins and Angelo Joaquin Jr.

p. cm.

Includes bibliographical references.

ISBN 978-0-8165-2818-9 (cloth : alk. paper) —

ISBN 978-0-8165-2819-6 (pbk. : alk. paper)

1. Chana, Leonard F. 2. Tohono O'odham artists—

Biography. 3. Chana, Leonard F.—Themes, motives. I.

Lobo, Susan. II. Chana, Barbara, 1945– III. Title.

N6537.C462A3 2009

759.13—dc22 2008047133

[B]

Manufactured in South Korea

on acid-free, archival-quality paper.

14 13 12 11 10 09

6 5 4 3 2 1

SPECIAL THANKS

This publication was made possible in part by a generous
subsidy from the Southwestern Mission Research Center (SMRC)
in Tucson, Arizona.

In honor of Leonard Chana

—CAROL G. CHARNLEY

In memory of Leonard Chana, honoring his
gifts to our community

—LAURIE MELROOD and BLAKE GENTRY

In memory of Evelyn B. Ulmer, who, with
Leonard, taught that gifts must always
move

—MARK ULMER and CARMEN BARRERA

Contents

To spend a few minutes with Leonard Chana was to be transported to a time and space where the Tohono O'odham Himdag, or Way of Life, was paramount. The respect and honor placed upon others that we had experienced in our youth—I was born fifteen months after him—was again revisited. While our talks often covered serious topics, I certainly remember the laughter that accompanied our reminiscing, which was heightened as we tried to outdo the other with our stories. I especially treasure those exchanges that were spoken in the O'odham language.

I probably first met Leonard in the mid-1980s, but it was in late 1988 that we first conducted business. I sat with him in his home discussing an image for the inaugural Waila Festival to be held in January 1989. A few weeks later, he gave me a stipple drawing of an O'odham fiddle band whose musical notes floated to the clouds above and formed a contemporary *waila* band. Featuring dancers in the foreground, he had captured the festival's emphasis on the role of the social dance music in O'odham life—past and present. Indeed, he produced more than ten of the images used by the festival in its twenty-year existence (see, for example, fig. 34).

Whenever I'd see him, his handshake and smile would act to rejuvenate my spirit. Similarly, his images contain details so familiar to O'odham—serving to vividly bring out the smells, sounds, textures, and tastes of the desert—that one is instantly drawn into them. In

depicting the values and beliefs so cherished by O'odham, Leonard's artwork provides us with a strengthened sense of identity to, and connection with, our Ancestors. To our non-O'odham neighbors, I would imagine his creations renewed their love and appreciation for life in the Tohono—their desert habitat of choice.

As I read his words, I was reminded of his kindness and compassion. He truly demonstrated, through his actions and images, how one might spend one's life bringing about mutual understanding in this world. Thank you, my friend, for sharing your wisdom with us all.

ANGELO JOAQUIN JR.
Co-founder and Director of the Waila Festival
Member of Florence Community, Gu Achi District,
Tohono O'odham Nation

Foreword

You Can Almost Just See Home from There
—CAROLINE ANTONE (Tohono O'odham),
speaking about Leonard Chana's paintings

Seeing home, rendering home, healing home—this is the achievement of Leonard Chana's art and life. Chana's extraordinary images celebrate the everyday lives of mid-twentieth-century Tohono O'odham people, offer symbolic insight into what it means to be O'odham, and communicate messages about healing and empowerment for the O'odham community and beyond.

Chana was born in 1950 in Kaij Mek (Burnt Seed), now known as the Santa Rosa village on the Tohono O'odham reservation in southern Arizona. Born into a rapidly changing world, Chana grew up speaking his native language and participating in the traditional activities he later depicted in his paintings. Like members of many twentieth-century reservation-based families, his life was disrupted by the impact of Western education, particularly Indian boarding schools. Several of Chana's five older siblings left home to attend boarding school, and Leonard himself eventually attended Sherman Indian High School in California. Chana returned to Arizona, where he met and married Barbara Manuel in the 1970s while both were working for the Indian Education Office of the Tucson Unified School District. In the 1980s, Chana turned to art as a means of recovery from alcoholism. His devotion to art making—or, as Barbara Manuel Chana writes in the introduction, his "needing to paint and ink a story"—was profoundly rooted in a sense of community and the value of the group, not in the individualism characteristic of many mainstream Western artists.

The scope of Chana's artwork is broad and deep. Many of his paintings depict the joys of everyday Tohono O'odham life: coming together to play, to dance, to harvest, to make music; simply to be with one another in work and family life. In the accompanying narrative so gracefully presented by Susan Lobo and Barbara Chana, Leonard Chana speaks of the social context of these images, and his anecdotes reference the struggles Native families engaged in to provide for basic needs and to keep families intact even through the separations imposed by Indian boarding schools and economic forces. The texture of life is tangible in Chana's vivid images and vibrant remembrances.

Other paintings and drawings are primarily symbolic. In many images, Chana incorporates the designs of Tohono O'odham basketry to give, as he puts it, "that feeling of being O'odham." In Chana's words, one important design, the maze, represents the "life of the person or the group" (fig. 43). In discussing such drawings as "Purification" (fig. 16) and "The Blessing" (fig. 17) and the ceremonies they reference, Chana provides insight into the maze as a symbol of the cycle of life and the learning required as one moves through life in O'odham communities.

Many of Chana's images are intended to convey messages of healing, recovery, and hope. He recognized, through his own life struggles, the power of art to address substance abuse, family health, and cultural self-determination. The sphere of influences shaping his consciousness included the Red Power [American Indian movement] and the international indigenous rights movements of the 1970s and beyond. Chana was often asked to contribute images for posters, T-shirts, and other means of communication for community events, and these contributions are one measure of his artistic success. Yet Chana's own definition of success fundamentally included the well-being of the group, and he understood that the individual had the responsibility to contribute toward that well-being. *Beyond Survival: The Next Step Is Ours*, the prize-winning drawing Chana submitted to the National Congress of American Indians for a national poster contest in 1989, is an image that encapsulates these values (fig. 65). In his explanation of the significance of the symbols in the illustrations in Chapter 12, Chana suggests that cultural traditions are essential to going "beyond survival" and overcoming obstacles to a better future.

In addition to the importance of the content of his art, Chana had exceptional artistic talent. He taught himself the technique of stip-

pling (pen and ink drawing using dots, rather than lines) and developed a strong command of perspective and proportion in both drawing and painting. It becomes clear from the narrative that Chana, from a very young age, closely observed the art process and products of others such as his brother, local artists, and great masters including Michelangelo and Van Gogh. Rather than think of Chana as lacking in formal art training, it is more appropriate to understand him as having pursued a self-directed, lifelong study of visual arts methods.

Chana holds a significant place in the story of modern Native art history. He belongs in the ranks of other important self-taught Native artists who focused upon the everyday and are often referred to as "narrative genre" painters. These artists—such as Ernest Spybuck (Shawnee, 1883–1949), Jesse Cornplanter (Iroquois, 1889–1957), Frank Day (Maidu, 1902–1976), and Dalbert Castro (Maidu, b. 1934)—were driven to visually translate elements of worldview into material terms, for their communities first and foremost, but also for an external audience. Their artwork provides a glimpse into Native worlds and has the capacity to generate respect and appreciation in ways that words alone are rarely able to achieve. In addition, many of these artists used art as a tool for recovery on both a personal level and the community level. Each, like Chana, contributed to processes of cultural revival and affirmation that continue beyond the artist's individual lifespan.

Chana, too, is both inheritor and embodiment of other art traditions of the Americas. His images of work and life on the land have kinship with the mural tradition of Mexico that itself spread into the United States during the Works Progress Administration era of the 1930s. Like these movements, but on a specific community scale, Chana's images are "people's art" and celebrate the extraordinary heroism of common people's lives. Like these earlier predecessors, Chana's images are intended to instill pride and motivate action, thus catalyzing better tomorrows.

Chana's need to "paint and ink a story" is shared by many self-taught artists across at least two centuries of American art history. Particularly (but not exclusively) in the rural South, men and women at the margins of mainstream society have been driven by impulses of spirituality and creativity to create entire bodies of work that gave shape to inner visions. Chana's life and work can be understood as belonging to this fellowship of artists as well.

Leonard Chana's words and images are a gift that illuminates not

merely his own remarkable life but also the land and lives of Tohono O'odham people. The very deepest thanks go to Barbara Chana and Susan Lobo for giving sound to his voice and light to his art, so that all of us can share in his story.

REBECCA J. DOBKINS
Curator, Hallie Ford Museum of Art
Associate Professor of Anthropology, Willamette University

Leonard had a vast circle of friends and relations. Each one contributed in their own way to this book. Because this book was a number of years in the making, many directly contributed during the time of its creation. A heartfelt "thank you" goes out to each one. We also are very grateful to all those who organized the exhibit of Leonard's artwork and loaned art for the exhibit at Muse: Tucson's Home for the Arts in Tucson (May 2004), including Lynette Chana, Lynn Stott, Lori Conner, Monica Chana, Blake Gentry, Laurie Melrood, Al Peyron, Ero Poutinen, Ted Warmbrand, Keith Kleber, and Mark Bahti. This exhibit and the two that followed helped us tremendously in locating artwork and in photographing the pieces, some of which are reproduced in this book. The Tohono O'odham Nation Cultural Center and Museum held an extensive retrospective exhibit of Leonard's artwork at Topawa in April 2005. We extend our many thanks to Bernard Siquieros, Anya Monteil, Eric Kaldahl, and Alice Sahmie, whose vision and hard work made this exhibit possible. In January 2006, the Amerind Foundation in Dragoon, Arizona, opened a six-month exhibit of Leonard Chana's and Mike Chiago's art with a fabulous day of festivities. For this we are extremely grateful to John Ware and the staff of the Amerind Foundation, including Carol Charnley for her photographic work. Also, we gratefully acknowledge Dean Saxton's assistance with the O'odham language used in this book.* In addition, many kind friends and family gave generously of their time and expertise during the preparation

of this book. We especially wish to acknowledge and thank Anthony Chana, Byrd Baylor, Mathew Chana, Ivalee Pablo, Al Peyron, Terrol Dew Johnson, and Reuben Naranjo. Thank you all!

Many thanks also to all those at the University of Arizona Press who worked with us in creating this book: Patti Hartmann, Harrison Shaffer, Nancy Arora, Barbara Yarrow, Miriam Fisher, and Carrie House.

*Dean Saxton, Lucille Saxton, and Susie Enos, *Tohono O'odham/Pima to English, English to Tohono O'odham/Pima Dictionary*, 2nd ed. (Tucson: University of Arizona Press, 1983, 1999 printing).

Introduction
Barbara Chana

Months after Leonard's passing, Susan Lobo spoke to me regarding the work she and Leonard had started, wanting to know if I wished to complete his goal. Initially I was uncertain, but then agreed to the undertaking. The reading and sorting through his comments was painstaking; taking hold of his thoughts and his vision meant careful consideration of placing words and meaning appropriately—he intermingled O'odham, English, and slang from both languages.

Leonard was a reluctant artist. His education taught that "true" artists came from recognized art institutions and had learned specialized techniques. His art came from just "drawing"; it had always been in him, and his technique was learned from picture prints out of the newspaper. Using pen and ink, he used dots to express himself—a style called stippling. In the beginning, he would sell his art as a means to make ends meet, not deliberate action toward being an "artist." In tribal tradition, one does not name Self, even if aware of the gift carried. Leonard never thought to call himself an artist; it just didn't occur to him. It took some time before he accepted the title and then only after people challenged him to value his gift. Leonard stated his inspiration came from his heart, which moved his hands to express his thoughts and feelings, which usually included others—viewing art as more than him. This belief, in my opinion, helped downgrade the false

pride and ego that can so easily beset an artist. He had a greater insight of needing to paint and ink a story than the need for recognition.

Leonard's life experiences not only came out of the O'odham way of life but also included the '60s and '70s era of Alcohol, Drugs, and Rock 'n' Roll. The '80s brought him to an edge—choose sobriety or continue the substance abuse. "I was thinking of quitting anyway" was a simple statement of knowing that change had to happen. His art provided healing for a wounded heart; he gleaned the best from his broken spirit.

I regret Leonard was not able in the taped conversations with Susan to share information about his later art pieces or to speak of the relationships he valued. Little was mentioned about his mother, Marie Chana. She was a woman of keen perception who recounted life events in great detail, in the same manner as his art. I remember sitting at her kitchen table, listening to her describe an event in her life to the smallest feature, with pictographic words. On occasion she would display a photograph to complement her story. In actuality it is her legacy that Leonard carried out through his art. Leonard also did not mention his relationship with fellow artists. Al Peyron, artist of photographs on stone, was one of his closest friends; if you saw one, you knew the other was close by. They frequented fairs and embarked on many artistic road trips. Al also had the honor of providing the "in" place for many Native artists—a type of sanctuary where members became a brotherhood and where standards and accountability could be found. There, among peers, art was discussed and critiqued, techniques shared, price value decided, marketing information shared, camaraderie and mischief engaged in.

Moreover, Leonard had the gift of friendship. His art has specific value but his friendship was priceless. His humor, his smile, his honest acceptance could not be masked. Leonard knew how to be a friend and guarded close relationships. He protected what was important to his life.

Leonard's talent had no set time and always required tending to, much like for his father who saw to his garden and customers. He was deliberate, steady, and detailed—careful to capture the spirit and emotion of what he wanted to be seen. His studio was our home: the living room, the kitchen, the dining table, and any other space needed to complete his work. Not a member of the family, pets, or furniture escaped the paint meant for canvas. Those who are artists,

or live and interact with artists on a daily basis, understand that daily life flows around their creativity. As for me, the memory of catching him between brush or ink stroke is held tenderly within my heart; it comforts me. As steward of his art, I work to maintain the integrity of his work. Eventually our daughter, who was raised under his easel, will assume the task. He is deeply missed.

Introduction

Susan Lobo

This is Leonard Chana's book. These are his words and artwork that fill the pages; he is the principal author.

The narrative here comes from conversations during many months between Leonard and myself, which we taped and I then transcribed. It is these transcripts that form the basis of this book. Work on the book stopped in the summer of 2003 when Leonard became gravely ill. When he passed away in January 2004, I put the project aside. A year later his widow, Barbara Chana, and I once again began to work on the manuscript, bringing it to what you now hold in your hands and, we hope, what Leonard envisioned from the beginning.

As Leonard and I considered each of his art pieces, he would lay it out on the table, and we would look at it, slowly and carefully, often for a long time, silently. Then he would talk about it, not at first specifically what we were looking at, but more often sharing the story of the journey of relationships and creativity regarding how that particular artwork came to be. This was important to him. He would talk about how the idea to do it came to him. Most often the motivation to create a particular artwork was from experiences or a relationship he had with someone else or, just as likely, someone had suggested an idea to him or even asked him specifically to create something for an organization or for a community or family event.

At the beginning, Leonard stressed to me that he wanted the book to be "about my art, not about me," but as he talked about each artwork

laid in front of us, he told of his life experiences and the people he had known that had led to his creating that particular piece. He described how ultimately those experiences are intimately entwined with the nature and essence of each piece. So our conversations, although based on a general process of starting from the artwork itself, then moved in all directions regarding his life and times, the O'odham, and the desert land that inspired him and was so essential to his work. We came to realize that this book is about his artwork as seen through his life experiences. At the same time, it is also about his life as reflected in his discussion of his art.

I often think that an essential reason why many people, especially Indian people, O'odham people, identify so strongly with his work is that he incorporated so much of the often-subtle details of O'odham life into his work. Many who know his art often say that it pulls them right in, bringing them back to their own personal visions and remembrances of their childhoods on the reservation and the family and community life they experienced.

Often after one of our conversations as we were working on the book, I would literally be in awe of the artwork he had shown me and we had discussed. I would ask myself, "Where does this fount of creativity come from? How can it be?" Now, in looking back, I think that Leonard took hold of the world, his world as he knew it, and explored it—the vast meanings and understandings as well as the smallest details; the ceremonies that bring health and wellness to O'odham communities, as well as the littlest creature sitting on a log in one of his paintings—and he played with it, showed the smiles and the relationships, the fun of life; and he transformed or re-imagined it; and then he made it visible for all of us, as a way of sharing his gift.

His artistic creativity seemed to be going on all the time, at many levels simultaneously: the dreaming; the remembering of times past; the passion for life and everything living; the problem solving in getting something just right in a painting and, as he often said, "the way I see it in my mind and my heart." He expressed in his art, as a teacher would, his perception and vision of generations of O'odham being, memory, and experience; of the persistence of a People; of communities and the foundations of culture. He made it come alive for all of us. What the medicine person sees and knows, the rest of us can dream dreams about. The artist makes the invisible visible and affirms all these things as well. This is what Leonard did.

The period that Leonard depicts in his art and speaks about here was a time of transformation for the O'odham, resulting from many external pressures and influences. With the increase in wage labor in the cotton fields off the reservation and the broader mobility that cars, rather than horses and wagons, brought, there were fundamental changes in family life and the economy. Young children and youth sent to distant government-controlled boarding schools interrupted the traditional flow of learning, ceremonial life, and social integration as that age group became absent from Tohono O'odham communities. The Second World War additionally removed young men and women from their communities for long periods of time, creating the loss of a segment of the population that had always been important for the well-being of communities. As the Anglo population and influence increased in towns and cities close to the Tohono O'odham reservation, people increasingly traveled "into town" for shopping, entertainment, and visiting relatives and friends who lived there.

Some of these pressures and influences, such as the boarding schools and the introduction of wells and cars on the reservation, are explicitly spoken about in this book. Also included here is mention of the long-term impacts of the Second World War and the tightening of the border between Mexico and the United States, as well as the role of Tucson and other towns and cities near the Tohono O'odham reservation. These have been significant influences in O'odham life, both on and off the reservation, and are a part of the larger social context that Leonard's art depicts.

Among the O'odham there is neither a long nor an active tradition of pictorial art on paper. Basketry and pottery are the best known types of O'odham art, yet these, in the past, were made primarily for practical ends, while at the same time being expressions of O'odham life and aesthetic. Only more recently have these come to be given the designation of Art by others. In O'odham tradition there are many very artful ways that music, song, dance, and the recounting of stories have been and continue to be important parts of the culture, yet these are not considered as Art, separate from, or somehow segmented off from, the rest of daily life. During the time that Leonard devoted himself to his artwork, there were only a few other Tohono O'odham artists who considered this a profession. It was years after he began creating art before Leonard used the word "artist" to identify himself. Even then, as he said in our taped conversations, "I'm only an artist."

When Barbara Chana and I began the task of transforming the forty hours of transcribed tapes into a book manuscript, we were faced with a number of editorial decisions. We knew that a priority was to have a very light hand in this process, in order to maintain Leonard's speech patterns and his meanings as much as possible. Sometimes she and I agonized over a sentence, word by word, making only the most minute change, just enough so that the reader would understand the meaning. We only occasionally added words, and then only reluctantly so, placing these in brackets when we knew that a reader would not otherwise follow a line of thought or would not know a local place by its abbreviated reference term. In very few instances we changed or left out a name to preserve anonymity.

Often, as Leonard talked about his art during our taped conversations, he would begin a topic, return to this same topic the following week, and then once again, seemingly out of the blue, return to it weeks later. In bringing the transcripts together to form a book, Barbara and I often had to meld these comments that were originally separated in time into one comment. Because the process that Leonard and I employed during our taped conversations was to focus first on an art piece and then let the conversation flow out from there, this book is not what could be considered a standard autobiographical format that moves chronologically through one's life and strives to include all aspects, including the developmental sequences of that person's art. Here, Leonard's commentary about his life is told as reflected in his art. During the editorial process we placed these reflections in a semi-chronological autobiographical order that referenced the content of the artwork and his accompanying comments, rather than placing the artwork chronologically based on the dates in which each piece was created.

Leonard was concerned that his art and what he had to say would be widely accessible. During our taped conversations, we'd occasionally pause and I would ask, "Do you think someone in a place like Philadelphia who reads our book and doesn't know anything about the desert or the O'odham would understand that?" Later, when Barbara and I began the process of transforming the taped conversations into a book manuscript and Leonard was no longer with us to offer guidance, we were very conscious of Leonard's intent and tried sentence by sentence to both maintain Leonard's manner of speaking and be sure that our hypothetical reader in Philadelphia would come to clearly understand

the depth and beauty of Leonard's work and vision, and the southern Arizona Sonoran Desert that he has depicted.

In the not-always-easy task of moving the transcribed tapes to a written form, we were challenged to maintain the O'odham oral traditions that characterized much of Leonard's speech. We had to strike a balance between keeping his voice and style of expression intact, while at the same time being sure that readers not familiar with O'odham English cadence and mode of speech could understand both his intended meanings and O'odham customs and traditions. In the same way that people who knew his art well often said that it drew them right in, we wanted to be sure that his words in this book likewise drew those reading it into an understanding of his perspectives on his art and life.

During Leonard's early years the family was frequently living and working in a cotton-picking camp near Picacho, Arizona. At that time, within the family, O'odham was the predominant language, so this was Leonard's first language. When he started school in Picacho, as he describes here, he learned English as a second language. His style of speech reflected the fact that he was bilingual throughout his life, and he spoke English in a way that is characteristic of many O'odham for whom English is a second language. English-speaking non-O'odham who live in southern Arizona become accustomed to the soft-spoken tones of the O'odham-English speech patterns and to the distinctive use of pronouns and tenses that often confuse those not used to hearing them. Spanish was also a second or third language for many O'odham during Leonard's youth, so although he did not speak it, he was very familiar with it, and Spanish intonation sometimes could be heard in his speech. Also, there are a number of Spanish loan words, such as "olla," that have been incorporated into spoken O'odham, as well as the English spoken by Tohono O'odham. These too are found scattered throughout the book. As we worked on the manuscript, we often faced changes in terminology that had taken place over time. For example, before tribes strongly asserted sovereign nation status as the Tohono O'odham now have done, the commonly used term for the homelands was reservation. Here we have continued the use of "reservation" rather than "nation" because this was Leonard's usage.

As he talked, Leonard often included O'odham words and phrases that expressed more clearly than English what he was saying. When he included O'odham words in a title to an artwork, as he often did, he

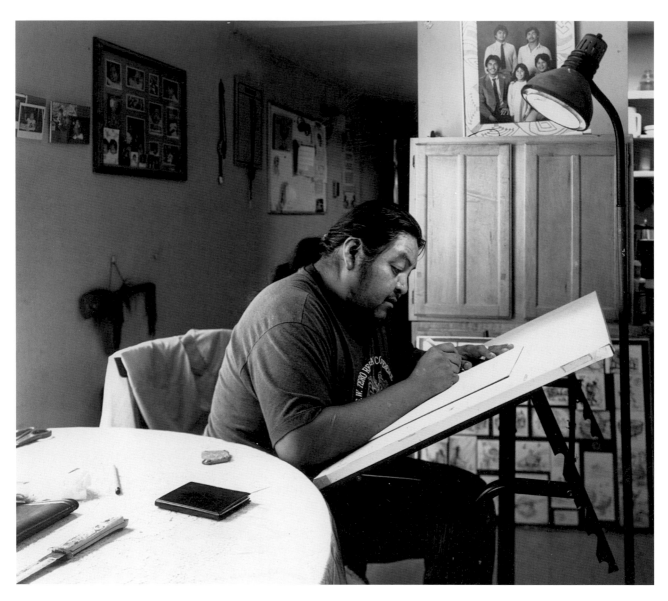

FIGURE 1. Ross Humphrey, "Leonard F. Chana
at work in his home"

consulted the dictionary by Saxton and Saxton (1969) for the written
form of O'odham verbal speech. In our editorial process, when there
were O'odham words in the transcripts, we, following Leonard's lead,
turned to the second edition of the dictionary by Saxton, Saxton, and
Enos (1983). We also chose to use the Saxton orthography, because the
Saxtons often spent time in the Santa Rosa village when Leonard was
young, and the Chana family was familiar with them. Again, regarding
the use of O'odham, Barbara and I, in our editing of Leonard's style of
speech, changed as little as possible but kept in mind that we wanted

this book, as Leonard also did, to be accessible to a general public. But even we, at times, had to ponder and discuss a phrase at length in order to fully understand the meanings conveyed by Leonard's words.

There was also a crucial and very characteristic aspect of Leonard's speech that we wrestled with in moving from the oral taped conversations to the written word. Leonard laughed—laughed a lot. Often a sentence would trail off with a laugh: a pause and a laugh that implied all the unspoken shared understandings between him and the person he was speaking to. This, along with all of the minute nuances of body language, was an important aspect of the way he communicated. Yet these do not translate easily onto a piece of paper. In creating this book, Barbara and I pondered how to convey the laughter and the many sentences that were not completed with words. We decided that even though it seemed a bit intrusive, we would place "[laughing]" in the narration in places where this was an essential part of what Leonard was saying.

Regarding Leonard's discussion of the ceremonies and the medicine people, we put thought into what should be included in the book, and what was better left unsaid. Often during the time that Leonard and I were taping our conversations, I asked him as he began to discuss spiritual aspects of O'odham life if he would like me to turn off the tape recorder. He most often requested that I continue to record, with the thought that at a later time he would decide what should and should not be included in the book. When Leonard's illness struck, that later time never came, and the decision-making became Barbara's and my responsibility. Leonard spent most of his youth in the village of Santa Rosa (Kaij Mek; Burnt Seed in O'odham). Each village is a little different, and each person reflects the way he or she has been taught. Included here are his perspectives and his words regarding ceremonies and the medicine people.

What follows is about one man's life and his work.

FIGURE 2. *Art.*
The creation of art comes from the heart, to the brain, through loving eyes, and out through the caring hands of the artist. Sometimes the absence of hands causes the heart's devotion to come out in other ways of expression.

The Sweet Smell of
Home

Mom and Dad
That's How They Got Married

My mom was born in 1911 and my dad was 1910. I wasn't too sure, but he always wanted to be older than my mom, so it seems he was always picking the year before. [laughing] He didn't want to be younger than her. That was around that time. A year or two older.

The relatives on my mom's side moved back and forth. They came from up that way to Pisinimo, then to Covered Wells, and then to Santa Rosa. My grandfather and my grandmother also lived in Florence, and that's where they ended up. They would have stayed there, but my grandfather died and then my grandmother moved back to Santa Rosa, and that's where we stayed.

At that time there was no border [between Mexico and the United States] so you didn't worry about it. It was all one. [They were] farmers, just like everybody else. That's just what they did here, because they would get paid more than if they stayed in Mexico or went to Mexico. So they didn't have anything from the beginning. They would go work over in Mexico for the different farmers, and they got what they could, food or anything, trade for work. And sometimes, I guess, money, but it wasn't too often. But over here when the white people started doing their stuff and they gave a certain amount of money and that's why more [O'odham] people came here, because they needed the money.

The Mexicans owned the fields and some of the stores. My mom's uncle who grew up working in the Mexicans' fields was more advanced

1

with what was coming. The Mexicans always told him, "There will be more white people coming and you have to learn the language in order to continue." Her dad also did the same thing, because they grew up on the farms and used to work with the Mexicans in the fields and then started working in building the Hoover Dam. They learned from them that pretty soon things are going to change, and everything will be done in English; that it's going to be dominant around the area, and they should get their kids to go to school to learn English and know what to do when it is time for them to get out there and work.

Earlier, it wasn't up to them; it was up to the chief. A lot of them didn't do it, because the older people didn't like it; they didn't want their kids to leave. "They're supposed to be here to learn our ways, continue our way of living." Some of them came willingly because they were curious, and some of them took their kids and hid them away so they wouldn't take them. A village that is way out there, he said, "No, you are not going [to school]." Then they sent the cavalry after them. He took the kids and went up the mountain before they came. They called in others, like the sheriff and the cops around there, and they all went down there to go after them. They finally got them. At that time, there still were troops, people on horseback, cavalry. They all went up there to arrest the guy, the chief, and got the kids and then sent them to school. People that were the last to hold out, they were called Huhhu'ula. They're all on the west side of the reservation.

At first when my mom wanted to go to school, my grandfather didn't let her go. They said, "No, it's only for the *checheoj*, for the males." So she didn't go. At home her uncle, who used to be a cop in Santa Rosa, was the one who was telling her, "You know, you have to go to school." He was the one who picked out the first group of O'odham kids they were going to send to Phoenix Indian School. That's when they opened up to go to school, and also the time when they let the women go, because they didn't let them go before. It was just for the men. Then the following year, they started taking more girls, and one was her relative. So she went and told her mom that she wanted to go to school because this cousin was going too. Her mom went to her dad and told him, you know, that this is what she wanted to do, because they are letting the girls go. It was night. She was lying there looking at them. But they didn't say anything I guess, and then one time her mom came and

told her, "I guess it is O.K. if you want to go since everybody else is going." They never went straight there and asked him. It goes through the mother and then the mother tells her. So they agreed to let her go. I think she went up to fifth grade or fourth grade.

She was telling me that she had this girlfriend who lived there too. She wanted to go, but she was raised by her aunt and her grandparents. They were too traditional, and they didn't want her to go. She told my mom that on the day they were leaving to let her know and she would be ready, "I'm going to go get my clothes and I'm going to meet you when they come to pick you up. They'll be going down the road and they'll stop and pick me up . . ." But the aunt found out and took her clothes and kept her home. So when the bus came to pick them up she couldn't go. Not too long after that they said she died, maybe from a broken heart for not doing what she wanted to do. They were mean to her, always making her work so hard. That was one of the things they did, they worked so hard so they didn't want to stay around at home. [laughing]

[My mom] went to Phoenix [Indian School]. She said she liked it, thought it was great. She didn't want to quit. When her dad died she didn't go back after. She didn't go see his funeral, but at the end of the year, she didn't go back to school. She wanted to work. Her sister used to work up there on Mt. Lemmon for somebody, domestic work. [Many non-O'odham from Tucson had homes on nearby Mt. Lemmon where they went on holidays and in summer to escape the heat.] And she was going to get married so they sent my mom to work up there. Her uncle was the one who was checking things out. He heard about some of the girls that would take off, run away, and end up messing around in the city and have all kinds of drinking parties and have babies without a husband. That's what they were afraid of. So he went and started looking for a husband for her. Then after my grandfather died they called her back to marry her off. They said they had found somebody for her to marry. She said, "I don't want to get married. I wanted to stay here and keep on working." But they called her back and told her she had to be in Santa Rosa to meet my dad. I guess they already knew each other, but that's what they set up. When she got home, the teaching started: how to be a wife and not to do certain things, and what you got to do, and how to treat him and stuff.

But my dad went through a different thing. They almost married him to somebody else. He was taken by his grandfather who was a medicine

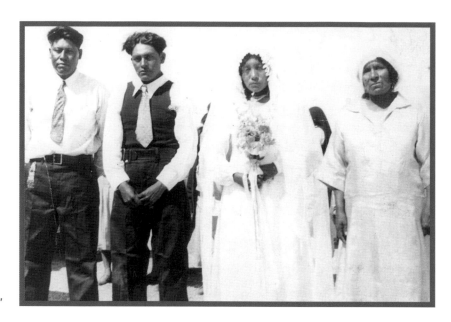

FIGURE 3. "My parents' wedding"

man from San Xavier. A lot of people came to see him [his grandfather] and they paid him. They brought either sugar, salt, or kinds of groceries to pay him. Some of them would pay him with cattle, horses. They didn't have enough room there because they planted stuff, so they took the animals to their summer homes. [Many O'odham moved seasonally to take advantage of the rainfall and therefore had various established places that families used.] They would go down there sometimes. So they took the animals down there, and they told a nephew to send somebody down there to watch the cattle and horses, to take care of them. So he sent his daughters. That was my dad's aunt. They didn't have enough men, so they told him they needed him to come work with his dad to take care of the animals. They had two boys, sons I guess. They were there, but they weren't old enough to take care. They didn't know what to do. So they wanted him [my dad] to take care of things and teach them so when they get older they could. He was eleven or twelve. Those kids were six or seven. So he went down there to stay. They didn't let his dad know. He was cotton picking. The only one that was there was his mom, so they told her. They took him. So that's where he grew up, learning to take care of the animals, learning to plant. When he was sixteen or seventeen, he thought the boys were old enough to know what they had been doing, so he left and went to the cotton fields and started working there [as a wage laborer for Anglo farmers].

He got a message from his dad that somebody had come and wanted to marry off their daughter. My grandfather had to go to the cotton field to find him and tell my dad, "Somebody is coming to see you, and this is what is going to happen, so we want you to come to Santa Rosa at a certain time when she comes. So you can meet." He told him that on a certain day she's going to come down and be here, so come over and talk to her. We're related also. She was from a place near Santa Rosa, but the family moved up to Tucson. And so they came to ask him to marry her. She was the one that they wanted to marry him off to, but with all the talk going on about the girls coming to town and then "going to the side of the road," all the things he had heard about the city . . . so I guess he probably figured something like that might be going on, so he didn't come. He just stayed where he was in the cotton fields. [laughing] Never went to meet her. She came down and waited awhile. Then when they didn't show up, I guess they went home.

Then the next time it was my mom's uncle who went over there and talked to my grandfather. So he left word with him that somebody else wanted to give away their daughter. He had already known her. When they were teens, they used to meet at the dances. But they didn't do it like they do it now, walking around in the dark. We sat around the dance floor and if they wanted to dance with us, they come and pick us to dance, and dance, and then they go sit wherever they came. So my mom was telling me that she used to go dance with him when he would come and ask her. So they already kind of knew each other. So he came, and that's how they got married. They got together. So for her not to be running around by herself, they married her off to my dad, so from there everything started. [laughing]

My dad, he went to St. John's [Indian School in Laveen on the Gila River Reservation], but he only went one year because some friend of his wanted to run away and he told him to go with him, so they took off. They didn't want to go back, because they'll come after you; or if you want to go back, you go back, but they will punish them, put a ball and chain on their ankle and set them up, set them up in front of the cafeteria. Everybody who went to lunch or whatever, they'd pass by and watch them there. And other things, I guess, they would whip them and stuff, the [Catholic] brothers. So he remembered that and they didn't go back. So he never really went to school at all.

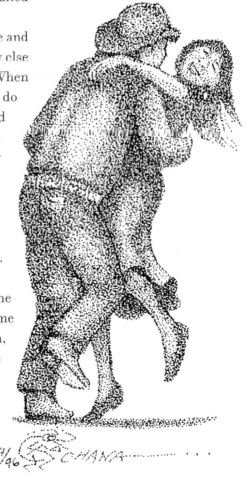

FIGURE 4. *Sharing the Excitement*

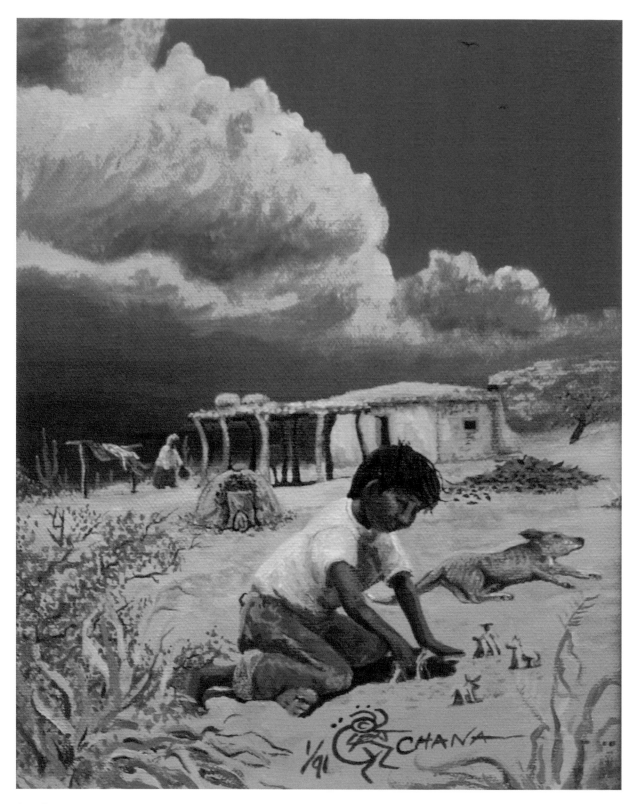

FIGURE 5. *Youth: Endless Time*

When I Was Little

We are different, the Indians, [in] what we consider success and what the other people that came [consider success]: the Hispanics, the whites, and the blacks, and other people who come and who look at themselves as number one. But for the Indians, we always look at the group; we share. It is the group that we all feel is valuable. Everything that we value, it's all in a circle. In the circle, everybody knows what is going on. It's shared between everybody. If they need something, it's all in there. It keeps moving and comes to you.

When you think about the living quarters, when we are in a one-room house everybody knows what's going on. Everybody knows what is happening. You know that you can live together and really understand your family. When there are people around you, naturally you become sharing. They share everything in that house. We had a two-room house. We slept in one room, and we ate and cooked and everything in the other. I remember when I was growing up that was all it was, up until we started getting water to our house, and then electricity. Then the T.V. showed up.

I remember when we were all there, there were about nine people all together, and we all slept in this one room. There were four brothers and two sisters. Actually six brothers and two sisters, but two of them died when they were young. I'm the tail. I never had a lot of time to spend with them. When they went away to boarding school, I really

missed them. I was real sad. You don't see them around; you don't interact with them anymore. They are gone. So I only knew them when they came home and started getting jobs. Then they would only come home for a week and then go back to wherever they worked, or go to school. It was me and then my sisters, two sisters, and all the brothers were at work.

SUSAN LOBO: Leonard began school when his family was living off-reservation in a seasonal wage labor camp for cotton picking.

I started going to school, which was in Picacho, just that one year. I remember being a little scared of all the kids that I had never been with, except the kids that were O'odham. They had all these kids: white kids and black kids and Mexican kids. I guess the first two days I was afraid and would cry, so they'd send my sister over to sit with me. It was just down the street from that camp there where we were living. Now when I go down there, just to see where it was, it wasn't too far. Yet, when I was small, it looked like waaay down. After getting used to those kids, then I was no good after that. [laughing]

I couldn't understand [English]. I guess a little bit. But still O'odham. Word by word—that's the way I understood. Like they say, learning English was different. I could learn the words, but I didn't understand what it said. I could say the words in the sentence, but whatever the sentence said I didn't understand. They would get mad at me because I would keep asking, "What is that, the sentence, what does it say?" But I would read the words again, and they got mad because it was the same thing. They whacked me with a piece of stick in first grade. They had Dick and Sally and Puff and all those. I couldn't. They'd tell us to read a sentence out of it, and I could pronounce the words, but I couldn't understand what it said. She kept saying, "What did they say?" And I wouldn't say nothing, and they would say, "Well, read it again and pronounce it." Then she got fed up and whacked me on the back. They used to do that on our hands. "Put your hand out." Whack! But it took me a while to really understand what I'm reading, instead of just pronouncing it. I could talk [English] and I could understand what they were saying, but just reading, I couldn't get it. But it finally came around toward the end. They used to do other things to just move you on from year to year.

They [my parents] used to give me a dime or twenty cents for lunch to give to the teacher in the morning. After a while I found out there was this soda machine, and it was ten cents to get a Coke. And I'd tell the teacher, "No, I didn't get ten cents." [laughing] So I'd eat lunch

and come out and get a Coke. The teacher caught me one time and that was the end of my soda-drinking days.

We used to stay in the cotton fields [to pick] until it's [the season's] all done, and then we'd come home [to Santa Rosa on the reservation] for a while. Then we'd go back again. That one guy who was the *maliom*, I guess the manager, he would come and pick us up in the big truck, and we go down there, wherever they take us. [My mom worked] for a while picking cotton until that one time that her friend Sara saw her, who was working for the government as a cook [at Santa Rosa Day and Boarding School]. The lady that was the head cook, she would get drunk and she wouldn't come in and then she got sick for a while. That's when Sara told my mom that she could come and take her place. "Well, I guess so." That's when she started working there, '57. They brought us back [to Santa Rosa] and that was it. We never went back to stay in the cotton fields. She started working at the school, cooking there until she retired, and we never left Santa Rosa.

There are different dialects [among the O'odham]. Santa Rosa has its own. The people south of Santa Rosa have a different dialect, a different area. The ones living in Ancgam, they have a different dialect, and it is just a half a mile or a mile over from Santa Rosa. The people from Pisinimo down that way and Santa Cruz, they might be Sand Papago [the Tohono O'odham people who live in the very dry region to the west beyond the reservation]. As you [go north of Santa Rosa to] Chuichu and Cockleburr, then they are sounding more like the ones from Santa Rosa, but part of it is the English since the kids [from these communities] used to go to school [off reservation] in Casa Grande. [By the dialect] you know where they are from. But mostly if you know who it is, you know where they are from.

When I was little I used to see drawings at home. I'd see different drawings. I didn't know who did them, and I'd ask my mom and she would say, "That's your brother, Tony." When I saw them, they looked real; they don't look like something he came up with. And I tried to see it. I saw it in schoolbooks that he kept, a notebook. He did a tank, drew a tank, and then one part started melting and you could see it

just melting into a pool. The one I really liked was where he started out with one piece, and in the next one it exploded and all these pieces started coming out. It was like four or five in different pictures as it went along. It exploded and the pieces came out to where it was all blown apart. I always liked that. I guess that was where my influence [to create art] first came from. When I saw Tony's work, it's more . . . he made it natural. When he would come [home from boarding school] to Santa Rosa, he'd draw different things. Yeah, he was the one who really started me out. It seems like it was just natural for him. I never talked to him about it.

My other brother always did drawings of dancers, but he was more athletic in high school at St. John's [Indian School in Laveen on the Gila River Reservation]. He would take part in the dances, different things. He would even draw the Indian sideways with the bonnet. He did those kinds of things. This was Bernard. He is the one that died back in '77.

I was thinking of the women that did baskets and what they must have thought about as they sat there through the day or through the night. I remember that my mother used to make baskets, and she would sit all night and make baskets and you know, I thought about what they must be thinking, you know on each line that they do. Some of them were like the squash blossom. I always drew that. And the maze—I always drew the maze. I wanted to show how much design they used. It gives it that feeling of being O'odham: how beautiful the artwork, doing the baskets and just the thoughts of whatever they were going through at the time. I've learned from other people what they mean, where they started from. They've always told me about that.

My mom, she was always doing sewing, like cross-stitches to make a picture. When she went blind and stuff, they worked on her eyes and she said, "I can see better." So she started doing the little cross-stitches to put it on the dressers. She was doing that for some of her cousins. I never got one. I was thinking about that later, but she had given them away already, before she died. Actually, before her mind went, my sister was doing that too, but I don't think she ever finished it. She was working on it. My dad mainly took care of the animals. His thing was growing beans, corn, and he knew how to do that. He had a green thumb. When the truck came in, all that disappeared. He did things with the truck.

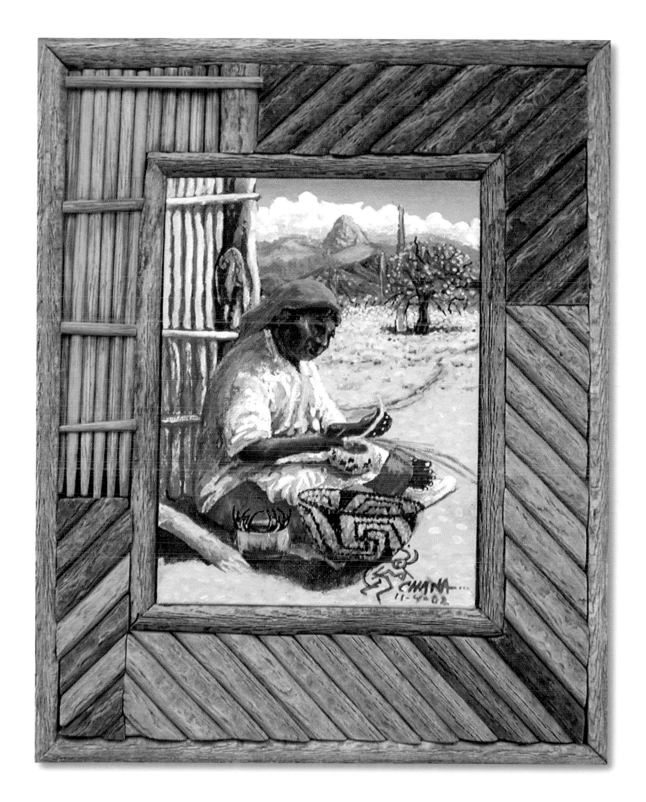

FIGURE 6. Untitled

When I was a kid, in seventh grade I guess, at Santa Rosa Day and Boarding School, this lady taught us how to do the watercolor: to put it on there and go over the detail. We did that watercolor and I really liked that. We first put the sky blue, pour water on it and move it around like this, and for the ground . . . and then draw out the picture. It came out real nice. I liked that. I had that picture for a long time. But I guess it burned in the house when it burned. She was the only one who really taught me, I think. Not that the other ones didn't, but they were mostly numbers and words. But she did a lot of other things like music. She had a selection of music from Europe that she brought back from Europe, and we used to listen to it, and I really liked that. She was at the end when I was going to go to another Indian school away from home. She was really strict, but she taught me a lot of things, even in math that I didn't know . . . [laughing]

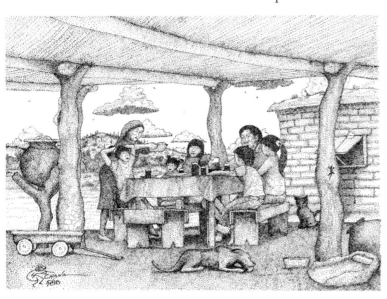

FIGURE 7. Untitled

Remembering the summers when we used to eat outside at noon. Of course in the evenings when you eat outside, you eat in front of the house because the sun's on the side and shading that part. It's always nice; it's nice to be out there. The family there (fig. 7) is four daughters and one son. They are handing over the food, and there is tea and Kool-Aid. Usually the water container is wrapped; it takes the heat out, refrigerates it to keep it cool. There are coffee cans on the legs of the tables so the ants can't get up. There is a wire hanging on the awning for the flies. Sometimes [in a picture] I put a chair, a table and a chair. Sometimes I make the door with the cross. A lot of times they don't have screens, just leave it open. They keep the door open. If it is closed they know that nobody's home. First thing I do is the house and just put the wood, logs in front of the door. And the dogs.

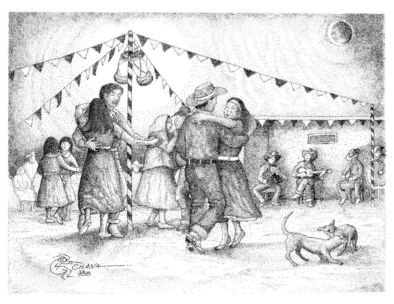

FIGURE 8. *Waila, The Chicken Scratch*

Some years they only come out like that . . . the watermelon will be

kind of patchy. It's not full or juicy. My dad, he'd put a fence around it with chicken wire and bury the chicken wires out so much and then put a double one around it so the coyotes won't really get in. When they used to do that, my grandfather would spend the evenings over there to shoo the coyotes away. He would take his violin, and you could hear him back there all night. We'd go outside, stand out there, and we could listen, hear him back there. There is a big palo verde tree with the trunk about that big. It's real big. And that's what he'd sleep under.

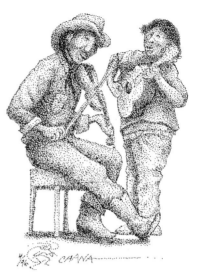

FIGURE 9. Untitled

It says on there [on the back of this picture] "Chicken Scratch," but *waila* is the real name (fig. 8). A snare drum and a bass drum. And then the lanterns because there was no electricity then. That's how they lit it up. With the bass drum, they are pretty loud. And when you walk there from a distance you could hear them playing. That was what I was trying to get. They had the Chicken Scratch at night and that's how they started it, by putting the lanterns. That's how they decorated, with crepe paper, to dress it up a little bit. Some people do that with everything. They like color, put a lot of color to make it look good.

Like I said, they used to have it sometimes from noon. Other times it's later in the afternoon until the sun went down. Then they went home. So that's what I was trying to get here. At night when there's nothing else, the people's eyes were clearer. At night you could see them dancing out there.

Sometimes it's at a distance and you ride your horse down there and some don't take their spurs off, afraid somebody will take them. The women's shoes have to be sturdy, because the ground would tear them up, especially at night. Most of them [guitars] are like this; they are not electric, but some you can tell they are. But I never put the speakers. The kids would look through the window to see who's playing. At first when you get there, you don't go out; you stay in the dark. [laughing]

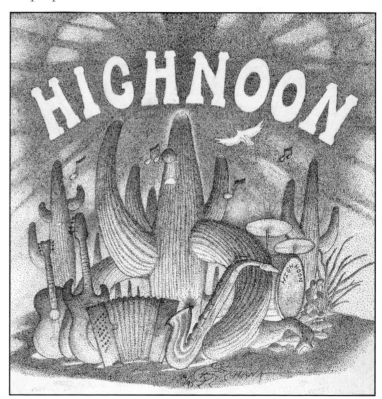

FIGURE 10. *High Noon*

My nephews just made a CD with their band. They called their band High Noon. Then when they went to do a taping, the person that was

doing the taping told them that they already had a High Noon, so they had to find another name. They called it the Horizon for a while. Now they call it the Desperados T.O.

We used to hear stories that the Apaches would come in. They wouldn't kill anybody, they would just take stuff, you know. Sometimes in the meetings, somebody would slip in. It was cold so they had a thing [a blanket] over them, and they slipped in and sat with them when they were having a meeting. Someone was trying to talk to them, and they would mumble, but they wouldn't say anything. Then when they went out, they would start asking, "Who was that?" And you know, nobody knew. [laughing] So they went out and tried to look for them, and they were gone already. Sometimes when they do that, they [the Apaches] would see how many people were there, and they would raid it or let it go if there is too many men. They talk about how they would sit in the trees and make hooting noises for different animals. Then when my uncle would get through telling the story and we wanted to go to the restroom, we don't want to go outside, especially by the trees that we have to go by.

FIGURE 11. *Toka*

My dad could tell which [non-Indian] ranchers had cattle out there and had cowboys that looked after them. Some of the O'odham if they'd get hungry, sometimes they would rustle a cow, butcher it, and take the meat. If they got caught doing that, they would send them . . . I think it was Alcatraz or one of those places. Some of those guys were sent up there because they got busted, sent them up and they never came back.

This lady used to teach out at San Simon, and she had a class with kids, girls who played *toka* [a traditional stick game played by girls and women]. The different schools, Santa Rosa and maybe Sells, they played from the reservation. So they taught them to make their own sticks, and they'd get together and play. She called one time and said they wanted a T-shirt design of toka players. So I did this one for them (fig. 11). This was back in '94, and they used it up until '98. I told them, "If you stop using it, I'll wait for a year

and then I'll start using it." So after they quit, I put some out, put some on T-shirts and prints. A lot of them recognize it. When I go sell over there, they buy their T-shirts.

That's when they told me they make the little thing with leather wrapped around it, they hit around, the two sticks. I think they are mesquite [wood]. They get them wet and they turn the bottom and they hold them there until they dry and then they stay like that . . . I think there was no real goal in the old days. But here they probably have a goal, and this is where you have to pass to win. But I remember in the old days, they would just keep going. They would be running waay down there. It's just who's faster and can hit that thing around.

[There was] a story of this lady that was really good at toka and would beat anybody. One time they were walking through this mesquite area; there was a lot of mesquite and she was coming, and these two young girls were coming. They met and she was talking about how good she was at toka. And the young girl said, "I'm good too. I can beat you any-time." So right there they started playing in the mesquite area. So I did that pen and ink (fig. 11).

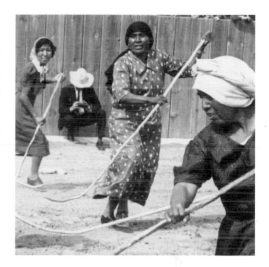

My mom was telling me they used to get frustrated sometimes, or there would be an accident and they would hit them on the shins, on the legs. So they have to watch that and wear long dresses, so it would hit the dress. But they didn't like it also, because sometimes the stick would hook their dress and pull it up. So they'd tie a piece of cloth like this around so the dress wouldn't be lifted up. She said she joined them at one point when Tucson started the rodeo, and they started different events. The different villages, they came to play the game, to compete. That's what Tucson wanted, them to come and play toka. They would go and practice out in Santa Rosa, the ladies there, and then when the day came, they'd bring them out. The second time they called them, she didn't go. She said she still hurt from one spot where she got hit in the leg.

My aunt always went, Aunt Molly. She was always a part. There were four or five women, her friends, who always worked together. They are the Sonoran Catholic group. They always set things up when it is time. And when they do this traditional cultural stuff, they are right in the middle of it. There is a postcard (fig. 12) where the ladies are playing that took

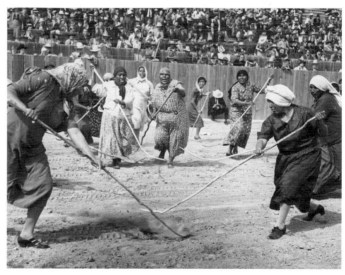

FIGURE 12. Unknown, "Playing *toka*." Leonard's aunt Molly is third from right. (Detail above.)

FIGURE 13. *Carrying Water for Mom and Aunt Molly*

place in Sells. My mom used to always tell me who these ladies are. "That's your *wowoit*. That is your aunt. And this one who is way in the back, she is always playing."

Carrying Water for Mom and Aunt Molly (fig. 13). I did that when I was thinking about my mom and my aunt. She was my favorite aunt, because she always joked and would tell different stories and be funny, so I liked her a lot. My mom spent a lot of time with her, and they'd go out and pick [saguaro] fruit early in the morning. When they'd first start, they would do it around the camp. Then someone would tell me, my grandma would tell me to take some water to them when it gets hotter in the morning. So when I did this, it was just special for my mom and my aunt, my aunt Molly.

I remember that [this game] is what we used to do when we were kids (fig. 14). They would get an olla and fill it up with a sweet bread, real small like this, little round, like muffins, a little smaller. They'd fill it up and put some candy, depending on whether they had some or had some money to buy candy. They'd mix it up in there. The way it's made—it's baked and so it's real hard. So everybody gets a turn at whacking it since it won't break the first time. The second time, you have to swing real hard to break it. So I just put that together [in this picture] and later on somebody asked me, "Do you know if the game started with you guys?" And I said, "I don't know." We've always played it, but I don't know where it came from. This one guy was saying: "Yeah, I think the Spanish, when they came, this was one way they kept their kids entertained. They would do that in their ranch houses at a celebration or something. That must be the way the O'odham got it from. They would pick one out that has a little crack in there; they don't use it so they hang it up." And you would think it would go real fast, but it still takes a big strength . . . a swing to break it. They would put a piece of cloth at the bottom, so when it fell, it would fall on there and everybody rushes in and grabs whatever they could.

[They have] *kaikia shuhshk* sandals made out of either cowhide or deerhide, but mostly cowhide. They used to. Then when they could afford to buy shoes when they get a chance when they go to town, they would get shoes, if they had enough money. Usually that's when they chop cotton and pick cotton; that's when they buy stuff. If they had shoes for me, they wouldn't let me wear it. The only time they'd let me

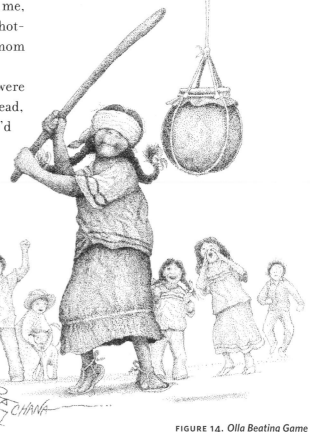

FIGURE 14. *Olla Beating Game*

wear it is if I'm going to church and to some doings and to where other people are, so they wouldn't make fun of you. [laughing] But I've seen some of the kids that are farther out or away from the villages and get to town and don't have any money to buy stuff and that's how they look. We've always been picking cotton or chopping cotton or something like that, so we always got shoes that would last for a while because you can only wear it on that time. And the rest of the time you would just put it up. I just ran around barefoot.

The children get together. Then you don't think about anything else, just what's happening right there. Sometimes they live so far apart, away from the village. So when I did end up coming around sometimes I always wanted to stay there. Sometimes I'd stay with my aunt who lived right there in the village, and other times I'd just go home. Sometimes, we don't even come out to some of the doings, but most of the time we do when it's the [Catholic] Church.

What I like is that children like my art. They like to look at it.

This is my first one [of this theme], so it is mostly lines (fig. 15). He's running this auto insurance on 6th Avenue now. A lot of people come and tell me, "I saw your picture over there." And sometimes I see them over there and they tell me, "Make me another one." They want more pictures of something. And the other one [the latest one] I had on cards is a little bit more closer to the way I was then. He has tennis shoes on now because they're at school. They look like my cousin's kids. I guess it's just that I want to express whatever I feel. Express myself. Or missing the times and my friends who I used to hang out with a lot. My cousin who died. It was fun to be a kid at the time, at a certain time, the sixties. Too bad they don't know those were the only happiest days [laughing], but you are growing up and you won't be doing the same thing . . . maybe you might be doing the same thing for maybe four years, five years, or maybe a little bit longer. But things change.

I always think about myself and how I was dressed. I remember how I looked when I . . . walked around with bare feet. And the girls too are hanging around too, but they are separate. They are in the background.

I always think in O'odham anyway, but I know in my mind that nowadays it's English, it's English first, maybe O'odham later. Those kids [in this picture] would be speaking O'odham. Probably O'odham. Even

FIGURE 15. *Buddies Forever*

then we spoke it mostly O'odham, but still there was some English in there.

They used to have some lizards that you don't see that much. They're about this long, and they are kind of like the color of the dirt, beige, and some have a deeper, almost a pink or red on the back. They are the biggest I know in the desert. They will come after you, like he is going to come at you, then he would stop. They will intimidate you. They can't bite or anything; they just look at you, telling you to stop. And we'd throw a rock at them.

Dogs are just our companions. The black ones are usually . . . a lot of Blackies and Yellows . . . Oam is yellow. However if it's a small dog . . . Tiny, but that is English. Judumi is Bear. Yeah. I used to call them by their age or something. Oks Kitty, that would be the mother cat, or old lady or old woman. My sister was the one who gives the cats names. It's usually by their color, or if they do something and she was seeing it, then she would give a name. She also gives the cows names, English names, like one had dots on its face and she called it Freckle, Freckle-face. Just different names.

We'd see the tadpoles in the desert, where they don't get disturbed. You'd see their eggs, and then later on, you'd see the tadpoles, the tail, then the legs, then the arms coming out, then they become shorter in the tail, and then they become frogs [Colorado River toads]. You know those frogs that get all puffed up, and if the dogs mess around with them too much, they let that air out of them. Or on their skin or something. They would emit something from their skin, part of the toxics. And if the dog inhales it, then he gets . . . weird. His eyes get all watery and he starts drooling. Now, we used to see them a lot and say, "The dog's drunk again." [laughing] And they'd just be sitting there looking . . . But they would recover, after about three hours or something.

I'itoi

He Is the One Who Taught the O'odham

We always use I'itoi because he's the Elder Brother. He is always a part of the ceremonies: how to do the dances, how to step hop, and what to sing. He is the one who taught the O'odham how to respect and show respect to the whole earth, to nature, and to the foods that we eat, the crops; and the dances; and the blessings. He is the one who taught them how to do things so they could stay sacred. The songs they sing are for the whole earth. We are just a part of what he taught, and what we learn. So I always use him in my designs that show anything that is important and sacred.

I don't know if he made it up, but he was the one who was teaching the O'odham when they first came onto the earth from out of the ocean. There were other things before they went into the ocean that had happened that disrupted the whole thing so it didn't work out. So they went back into the ocean. Whenever he called them back, they came out. This is what they learned when they were coming: the music, the songs; how to use the different plants in the desert so you can eat; what not to do; how much it means to the O'odham, because they feed off the plants there in the desert; and the weather, when it comes, the seasons and how to treat it; and the songs that they do for each one.

So he was the main one who took care of that, took care of the learning part—how sacred it is to have food, for the earth to grow your food, and the songs to sing for the rain, for the different seasons, when these plants come out. He is the one who taught the O'odham what to do once

they came out of the ocean. They knew a little bit, and then he taught them again about the plants, the things you plant in the ground, and the animals, and how you show your respect and appreciation by dancing and singing the songs, and by the basket designs.

That's the way he made his home [in the maze]. They said there were many other bad medicine men that wanted to kill I'itoi. When you kill him, then you can use his powers any way you want. But this way [because he is in the maze], it would be harder to kill him because you would have to go down into the center. But a lot of times they get scared and go back out because it's a long ways. Sometimes they die in there in the lines. That is how he kept himself alive and what he shared with O'odham, the People. That's what it looks like.

The other thing is it's the maze of life. I use the maze on the basket because it is considered that it is the life of the person or the group. They say you are born. That is where you enter. That's you when you are born. You start going through the maze of life, and every turn you make, a major event happens in your life as you go. And then as you go along, you learn about yourself, how you do things. Your body talks to you, will tell you when to change to something else when you need to and how to do it. That's the part with the Elders—that when you get to a certain age they teach you other things as you go, how to handle things. If you listen to your body and watch other people as they live, and you change those things, you live longer. When your body tells you to change, you are supposed to change to something else, learn something else as you get older. But a lot of times we do our own thing; we don't learn. Usually we are too busy to even notice what our body says.

By the time you get to the center there and you get all these messages that you never picked up from your body—what you need to do and what you need to change in what area, your mind, your brain, your arms, your legs or whatever—so you need to change your life a bit so you can live longer, and another part of the world will open to you so you can keep going. By the time we get down here at the center, they say, you stop and you look back at what you have accomplished in your lifetime, what you learned of the O'odham ways.

If your body aches, a lot of things ache when you get to the center, then you look back and you see where you didn't change your life when your body says you need to do something else. Your life is shortened, and your mind won't grow anymore because you are stuck in that time, and then you die sooner. But if you listen to those messages in your

body that say, "You've got to change here," then you live longer, your body will rejuvenate, and your mind expands more to what is going on around you—not just you, but things that are even farther out, like the universe, the moon and the sun, the stars, the seasons that come with it. So I always use the maze anywhere [in my art] when it means the purification, and the blessing, and the change.

This is the blessing that they dance when they bless the ground in the village for the following year that is coming up. They say they have to renew the blessings on the ground and on their homes. Sometimes there are different spirits that attach themselves to whatever they don't like, so they do the blessing again and that takes them all out of the area.

These men they call them *maliom*, which means they are the leaders. They are walking in front (fig. 16). They are the main singers. Everyone else that comes in later can sing also. But the dance is how they move along, because before they are just walking as they are singing, but at a certain part they will start using the rattles with more of an accent. The people change the way they are walking . . . then with one leg behind the other and that is because the clouds are slowly coming. And when they get there, it starts to rain. [Here] I made him [I'itoi] more human than he is in the basket. He has a rattle and a cane. I added a cane because he is an old man. But now today, it's just a symbol. But if you are a part of a group that is traditional, they use him all the time in their ceremonies.

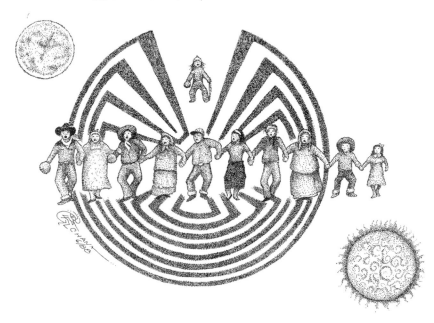

FIGURE 16. *Purification*

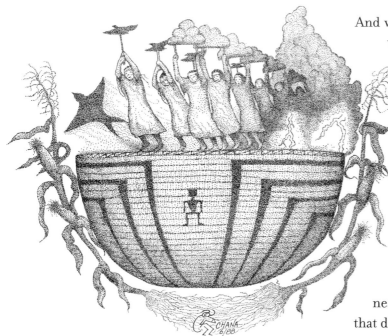

FIGURE 17. *The Blessing*

And with the dancing, the plants would grow more to survive through the winter until they start planting again. That's what the corn stalks are here [in this picture] (fig. 17). And then the rain comes in the spring, and that's what the clouds are. The people that are blessing are coming out of the clouds. This was a big one; my first real big size [drawing]. The corn . . . and I tried to capture the wind that is coming down. I put the dancers, the singers in the clouds.

Yes, that's what they are carrying [the clouds] and the thunderbirds. There is a row of boys and a row of girls on the other side. And that is just the dress that they wear. They have the solid white underneath and then they have a fluffy kind of thing on top that drifts. That's because they are the clouds that are coming. The smaller kids have the full dress at the end, if they are on the tail. The first group that is in the line, the grown-ups, they usually don't have . . . they just have the skirt and the ribbon, although I've seen others that are fully dressed like with the smaller kids. Every year they pick out the ones. Some of the older ones will stay in the position that they are, but they will get new kids to get behind them. What they do is give you that dress to wear, and the boys they don't want to wear a dress. My sister, she used to be a part of it. I used to go with her when they would practice at night, hang out and watch them. [They are] fifteen or sixteen or eighteen, depending on how long you hang out at home. Then they get older and somebody else takes over.

That little bug they call *juhki behedam*, that means "bringing the rain," is the first one that will show up before the rain comes. They will show up and fly around. That's how they know [the rain is coming]. They used to tell us to get that little bug and put black, you know, they cook and the bottom of the kettle gets black. We'd get that and put it on the back of that bug and tell them, "Go bring the rain!" But these guys show up first and they fly around. That's why it's coming out in front of them [in this picture].

Always when I would draw something, I would think of the basket and then I would put something on top of it. When I did this, somebody said to write something on it to tell them what it is; that's when I did this. [This is what is written on the back of the card: "Chelkona

(Chell-'ko-nah) The Skipping. Chelkona was held during or at the end of the harvest season as a thanks to the rains that brought plenty of food for the winter. It is also a rejuvenator of sacred images for self-healing at the first signs of certain sicknesses. Chelkona blesses the ground on which the village is built to rid it of evil spirits. The males carry the thunderbirds and the females carry the thunderclouds that carry the life-giving water to start the cycle again."]

This is one of the purification dances that come out sometimes when winter's starting, and then they do it again when the monsoons are [coming] . . . or before in the springtime so that we get lots of rain to grow stuff during the planting season (fig. 18). It's always what we want, reflecting a good planting season, lots of rain and clouds and the rainbow. The rainbow tells us that, you know, that the rain will be coming. They have other reasons, but that's how we know the rain comes either that same day or the next few days. That's when the clouds will come along and we know it's going to rain sometime. The birds are always around. I put them there to make it more natural, how it is, you know, any time of the day.

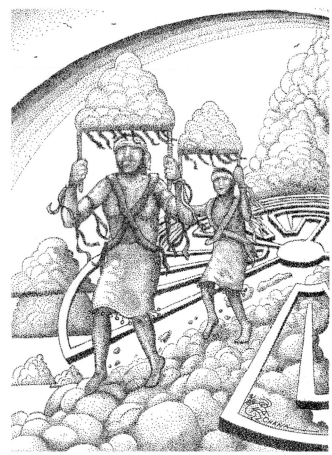

When they dance they are portraying the clouds, plus some of them carry the rainbow; some of them carry the thunderbirds and some of the men the clouds, like these two. It shows the rain coming down. That's purifying or blessing where you live and so you can have a good planting season where the rain will rain a lot. Then you have the planting and the crops will come up. There's two of them [growing seasons]: one is during the spring and then when those [crops] come out, you pick the fruit and you add a little more seeds in there and it will go on until the second season which is in July when the monsoons come. They rain on them, and the fruit will come out real small. But they ripen right away and they are really sweet, even though they are really small; melons, corn will also come out then. The first planting is like the corn or the wheat, or the barley, beans. They can do it again for the second planting season that starts in July.

We have a dance on the San Juan's [Day; the Feast of Saint John the Baptist on June 24], and after that's over, you get ready to go to your fruit-picking camps to take the [saguaro] fruit. Then

FIGURE 18. Untitled

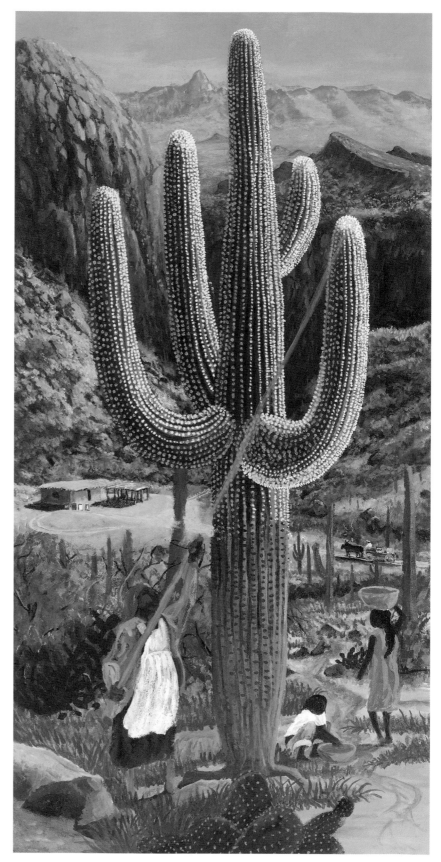

FIGURE 19. Untitled

that's when the rain is supposed to come too. So they go out and they stay at the summer camp for maybe two or three weeks, depending on when the rains show up, because they'll pick the fruit during that time. Then they come back and they make their syrups and store it. It's in July when the monsoons start to show in the sky that it's getting ready to rain. Before that, they've already started the planting. Then they set the date for when they are going to have the ceremony for the rain to come, when they serve the wine that they make from the cactus fruits.

Yeah, sometimes I'm not sure what I'm doing and I'll just work on it (fig. 19). I don't know how long it took me, but I know the background took me a while . . . I kept looking at it, kept working on it. Sometimes it will sit there for weeks and then I'll pick it back up. So I'm not sure when I started, or I know that was the time I was finished. And I look at that and I don't know what to do with that—the sky or the sun.

They're up on a hill. Yeah, that's why I like it. I can do the stuff that's not just flat . . . all the hills, canyons and then in the background, the distance, that area. I need to finish this one. I still need to add the dogs. That's always one thing I always like to have dogs and other desert animals, the birds and turtles. So I haven't really thought about the animals. But I know what to do here now, all in this area. And the clouds, I already know how to do that, but I always kind of leave it to the last, the final thing. And I need to add the [saguaro] fruits and to bring out the needles a little bit. The fruit, I'll bring that out more and add more of the little light at the edges, right along here, and down here, the light of the summer sun. The sun's coming from this way. And the wagon. That's pretty much done. It took me a while, since starting it about two years ago.

That is one I'm still working on now and then (fig. 21). I'm still working on that. I added . . . more people in the front there. I started it in '86 and then I started other things and then just never went back to it. And last year I did the rest of it down at the bottom. The top on the left, it's done. I figure the stuff that I've done already, I'm not going

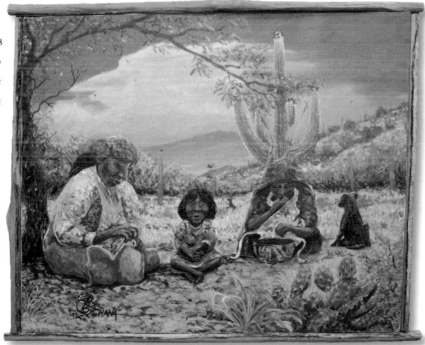

FIGURE 20. Untitled

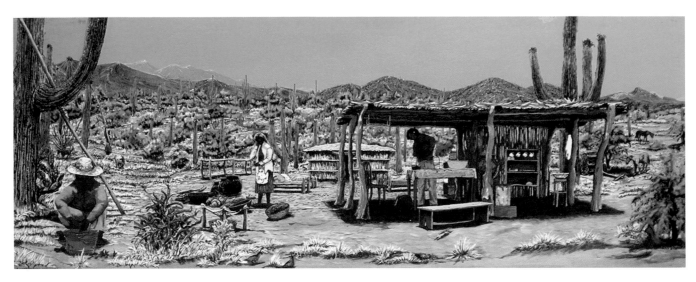

FIGURE 21. Untitled

SUSAN LOBO: Then Leonard returned to talking about the interrelationship between ceremony and farming.

to bother with it. Maybe just a little with some certain things. But I'm going to leave it like that, since it's a long time ago. These are two of my first ones I ever did . . . just messing around.

My dad used to go to the faucet, the community faucet, and take water barrels, maybe two or three in a wagon. He would go get it and bring it back and make little things around the plants, so bucket by bucket he'd water all the bean plants and all the sugar cane, the corn, the watermelon. He would do this for days, probably the first part of July before they [the rains] start to get to where we're at. Because it's already started. They know it's coming, but they still have to water the plants before, because they will dry up. That's why they'll do that during that time, you know, every day—go up there and water the plants. I don't know how many times he'd go to the well or the faucet, up until they set the date for the feast, the wine feast when the medicine men are saying that's when the rain is going to come.

So they set it like four days before and during those four days . . . or during the last two or three days, they dance the dance they call the *gohimeli* that they dance when they are asking for the rain and clouds, when you can see them coming (fig. 22). They do the dance two nights in a row. That's when they ferment the saguaro cactus wine, because it's the purification: to purify your body and the earth so the crops will grow, so you'll have plenty of crops to go to the next year. With the sun and the moon, the crops grow during that time. The sun does it to make them grow, and the moon also does it, but in a different way. They work together. This is what they told me. The wine helps them

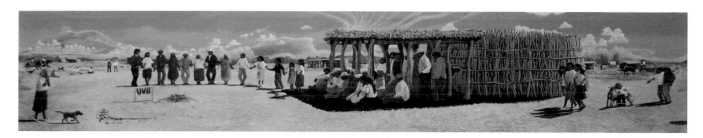

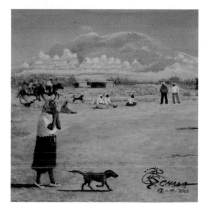

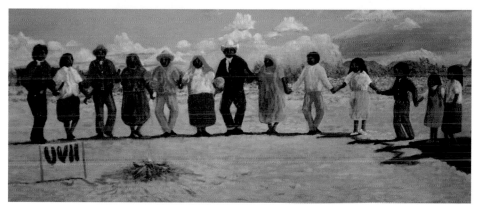

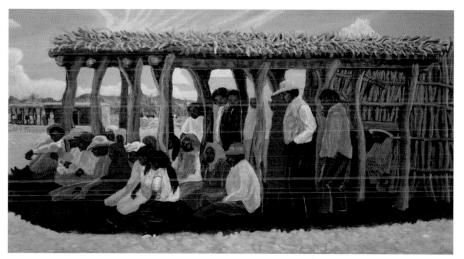

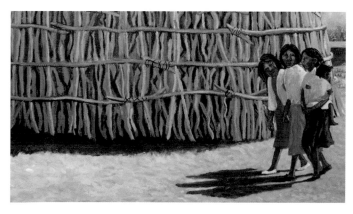

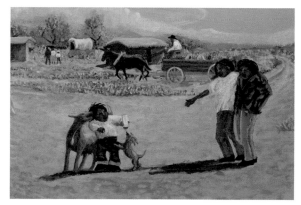

FIGURE 22. Untitled

grow more. We're cleansing our bodies by fermenting the wine of the saguaro fruit. Drinking it causes diarrhea, and that's how they say it cleanses us inside. It's ceremonial. Drink the wine and it cleans your body out. Back then it's only that one time of year. They don't drink any more until it comes to that time. It's always fun to know what's coming up, the different ceremonies that they used to do. People take about a month to get ready for it, which is always good too. You learn more things about what goes on and how they start to prepare for it.

[The dance] it's kind of, it has . . . when you move side by side. You put one foot behind the other as you move. They say that's the clouds coming, the rain clouds. When you do that, they sing their songs, rain songs, bringing the clouds. They'll do that two nights. The first one up until midnight. The second one up until dawn when it starts to light up. During that time, before that starts, they send a rider around with a can to each house, and each house gives them some syrup, you know, that they bring back from the [saguaro] camps. They mix it all up, and they make the wine and stuff in the round house. So the last dance that morning, they'll try it out to see if it's ready. Whoever is there during that time will drink some. Sometimes it's ready; other times you can kind of still taste the sweetness. But you know that by that afternoon it's going to be just right. So everybody goes home after they drink that, and then they sleep up until probably noon or some time. They meet back around three o'clock or two o'clock in the afternoon to do the ceremony. But before that they send the rider around again with the bucket, and each one puts in the wine they made at home. They'll put a cup in there as he goes around. Then they take that and they mix it

in with the rest of the wine that they already made in the round house. That makes it bigger. By noon it's pretty well done.

Then they have the ceremony. Going towards the end some people come and they bless the wine, and then they bring it out in baskets, in big baskets (figs. 24 and 25). They put mesquite sap in there to seal it well so it won't leak. When the circle is formed, they bring them [the baskets] out in the circle. They have the four directions. Villages that are on the north side will be sitting, of course, on the north and the same way with the south, west, and the east. Whatever village they're at, they always sit on the west side of where the round house is. Then when they bring out the wine in the baskets, they take it to the medicine man and the chief and they will bless this. He's on the west side, south side, north side. They have this speech that they go through each time as they go around and bless the wine. When they're finished, then the medicine man and the chief will drink from it. Usually it's the chief that did it. Then they give him maybe four little cups or cans and dip it in there and pass it around. Take it out and put it back and then start over again. First they drink it at first, and while they are doing it, they are blessing it and saying their prayers.

They say once they start feeling the physical . . . when it's good, it's really good. They have these little cups, a can . . . they drink one of those [but] you can hardly feel, or start to get drunk or something. When you do that, then you've got to sing your song, your wine song. When they do that and after they finish, then everybody joins in. They all start drinking. They get it from the basket and pass it around from the medicine man and they all share that one basket. They say as soon as you drink one and you start to feel it and you sing your song, by that time, everybody's singing. They're all singing their songs. Whatever's left in the round house, they keep bringing it out there, refill it and bring it back out. There's a lot of people around that. I have some pictures of this, where they sit around, and around them are horses that people ride in from their villages. It's pretty nice. Everybody gets to feeling good.

You can tell when it's [the saguaro wine's] well done when they give it

FIGURE 24. Man with basket at ceremonial gathering at Santa Rosa village. Marie R. Chana photographic collection.

(below) FIGURE 25. Untitled

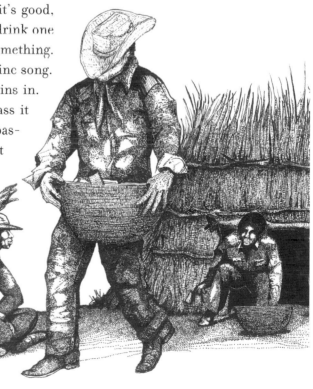

to you and you can smell it, the aroma. You know when you drink it, right away, you start to feel that, start to feel getting drunk. It goes fast because it doesn't take long before it turns into vinegar. When you taste it and it's sweet, still sweet, then it's really . . . and when it's ready, man, it gets you drunk even just smelling it. [laughing] When they give you those little cans to taste, sometimes they will fill it all the way up. If they recognize if you're a relative, then they'll fill it all the way up. And you drink it in one gulp. They'll say, "Who is that who's drinking just a little bit. Drink it all! Drink it all!" [laughing]

Probably around 4:00 or maybe 5:00 it's over and then the people go to invite their relatives, their friends, you know, people that they know to their house, because they know that their wine is ready to drink. Then they'll go to their house and do the same thing with baskets or just cans of wine in there—give it to their friends that they invited, and all these people will be there and they'll share their wine. They'll go from that house to the next, or you know, maybe two or three at the same time. And other places—somebody else will invite them to go to his house, so they'll go after they get through there. You know, it's just all over. People are riding around on horseback and wagons filled with old ladies and old men to take them to the other houses. By that time they're all really drunk. They say that when you throw up it cleans you out, and it also says it brings more rain to clean the earth. So that helps the plants grow. They say when it does that to you, you throw it up and it causes diarrhea which also cleans you out, all your intestines, everything out. That's really the purpose of this. It's supposed to clean the earth and help the stuff that they plant in it to grow. It takes maybe about three days and once it's [the saguaro wine's] all gone, then everybody starts to go back home when the ceremony is finally all over.

SUSAN LOBO: Leonard talks about the introduction of commercial beer and wine to the reservation.

But later on in the '60s, the only bad thing that happened, they started bringing in the other stuff, the alcohol, the wine, and the beer. And they started making raisin jack and stuff in place of the saguaro wine, and that messed it up for a lot of people. That makes it go on even longer, like five to seven days, you know. That's when the medicine men are saying, "That's not good," because it's only supposed to be the [saguaro] fruit. The purification has a certain time. After you've drank up the wine and stuff, then everybody goes home and starts their work and what they need to do at different times, the seasons. That's what helps everything work and keeps the power of the planting, and for

things to go well, stay for whatever length of time. But nowadays, they drink the other stuff, it never stops, and it causes trouble. It makes everybody go really crazy, and they just want to keep drinking and drinking and start fighting, and at times killings and stuff. It's not supposed to be like that.

That's some of the reasons why in some areas they quit doing it, because of that. The young people don't . . . at the beginning they mean well, but once all that fruit wine is out, they start bringing out their other stuff which is just not good. So it creates problems between the families, between friends. That's not what it was for—to bring families together so that the power will always be there, be a part of it. It's to bring your family together, your friends, and share your wine with them. Once it's all gone, that's the blessings, the songs that they sing. If you know the songs, you can sing along. Everybody has their own song that they get from the old songs that have been made up just for that. That's what they were after: to have a good planting season to survive on until after winter. What they get from the planting, they put away for food as the year goes on, up until they do it again, start planting again and do the ceremony.

So all that has a purpose and a strong meaning, but now it's more a . . . I guess if you're really into it, you believe in it, it happens, but the way I see it, when it's become a show, it becomes a classroom for people to learn. When you do it that way, it's not really powerful, because if you grow up with it, you're taught during that time as you are growing up and you're watching things that are happening—how the planting goes, how they pray over it, how they respect it—and over the year, this is what you do, what your power's for, and then it happens. Not when you go over there and you learn about it and then drink the wine. To me it's not long enough or strong enough for them to be able to produce that kind of a reaction that it used to be. When they sent the kids to high school [boarding school], that kind of cut that learning part. You may know certain things, but not everything. So it cuts that power-producing energy to make your plants.

You know, I think my first time I got drunk was when one of my uncles asked my mom to come. I went with her, and she got a little can, about that big. We were sitting out there and she was giving out to everybody else, and finally she said, "You want some?" And at first I didn't say anything, but she grabbed a little bit and said, "Here, taste it. See what it's like." So I drank that and after that I was feeling pretty

SUSAN LOBO: Leonard's introduction to drinking.

good. I must have been maybe seven or eight, or even less because I had to hang out with her. They wouldn't let me go anywhere else.

Also, that was the first time I had seen people drinking beer. My other uncle, he used to live here, but they moved to Ajo [a town just west of the reservation]. I saw them standing by his car, and they were drinking beer, and I always wondered about that. I wondered what it was like. But I don't remember when I first started drinking beer, but it was awhile after.

When my dad had gotten his first truck, people were coming and asking to take them to town to shop. After they did that, they'd buy wine, mainly wine. Beer and wine, that was what the older men were drinking and started drinking then. As they were going home, they would be drinking and singing in the truck. We were little boys, around nine or ten, somewhere around there. Then now and then they'd drop the bottle and we'd get it, just a little, like that. So I started drinking wine, hanging out with the older guys because that's what they had. Sometimes, when they'd get real drunk, we'd just take the bottle, and we'd drink it ourselves and get real torn up. It wasn't until after I came back from my first year in high school [Sherman Indian Institute boarding school] was when I started drinking beer. From then on it was just . . . went haywire. [laughing]

I've always wondered about that—my first drink was the wine. I was curious about that, you know, wondering what it would taste like, because they would have it in a chest with ice in there, and I always wondered about that. It made it look good, but I never'd drink that until after the wine, and then after that it was the beer. I used to watch my uncles do it. They would just drink it down like that. I'd watch the wine inside as they were drinking it, all those sparkles with the sunlight, you know. I guess that's kind of what I wanted to be like, was to drink that, have people look at me or something. Just that they would say all kinds of things about a little kid drinking and being drunk. And I always felt that that's what brought on a lot of . . . from the wine, and from the wine feast, but they didn't know when to quit, once the other stuff came in.

The reservation was dry, and when people did bring it in, they would sell it. It was always available from bootleggers and different ways of getting it.

Once it ran out, they are looking for it. If they can't find it, eventually they go home. But now it's like just down the street—catch the van,

make a run down there, and come back with cases with whatever money you have, you can afford, even when you can't afford it. [laughing] That's how a lot of people get killed on the road, because that's why they went down to get it, drink it, and get into an accident. Also in town [Tucson] with all them people that are prejudiced, a lot of them get killed on the way home, I guess. If they don't have any ride, they try hitchhiking, and they get run over by somebody that doesn't care. They never find the people that do that. Yeah. My cousin got run over there and nobody knew. They were talking about it. He had gotten in a fight earlier with some white guys. They were saying, "Maybe that's who did it," but nobody really knows. He just got run over, just going home. At first they hit him and messed up his arm, and then finally they finished him off. A lot of bad things happen. You can see how from drinking the wine and not knowing . . . and wanting more I guess.

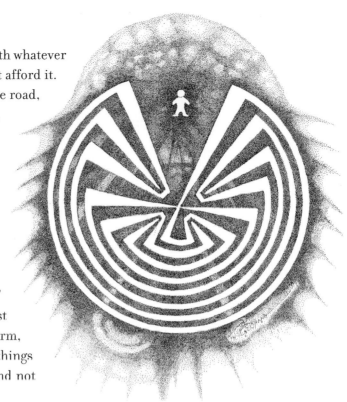

FIGURE 26. *Light of the World*

FIGURE 27. *The Way to Make Perfect Mountains*

Because I Can Feel It

*T*he *Way to Make Perfect Mountains* was written by Byrd Baylor. It had short stories from different tribes, the beginning of the tribes and how they got on the earth, and how they found their place where they're going to live. I remember some of those stories from when I went to boarding school in Riverside and I got to know some of the different tribes.

They had the medicine man on Baboquivari [Mountain] where they had to figure out about the land where the O'odham picked to live and to plant (fig. 27). Because there were mountains everywhere, there was no room to plant, so they had these four medicine men meet on top of Baboquivari to figure out what to do. One thing they came up with was to move the mountain. So they got the singers and the medicine man to meet and they sang. I don't know how long it took them to do the ceremony, but this is a little bit of what I thought about when they met and they were singing. The medicine man was doing whatever to move the mountain. And that's what's happening. They are moving it over so they could have enough room to live and to plant their corn and plants to survive on.

When they start, when the medicine men start working and the songs start coming out, everything comes alive. One of them is the dust devil and the coyotes that are back in the background. And just the motion of the clouds and the wind that's happening with the lightning and stuff. The way they did back then when people and their

37

powers were stronger and their belief is stronger in what they do, and so these things happen all around them. Things come alive: the ground, and the air and the clouds, the animals. You know, everything comes alive, even the flowers come up, the fruit, the turtles down here. They believed in the medicine man, that he could heal and do things. The songs that they sang aided him as he was moving the mountain. I had to put everything in there to connect it, to see what happens in all that action with what they were doing.

I did one before, a card, a small one. It came out real nice. I was just trying to see if I could get that dust devil just right. That one really came out really nice, but I knew that in our way of looking, that the dust devil is just what it is: a dust devil. When we were kids, we used to run in there and swirl. And one time my mom saw us and said, "Don't do that." And she was telling my dad. It may look harmless, but you never know. They've always said different things about it, most of it negative. You know, like that I think it's pretty, beautiful to see these things coming out, how they come out. But it's still dangerous if you don't know how to handle things; listen to what your Elders say.

It is corn [that] he picks out of the basket. This comes from the earth, and the yellow comes from the sky, and the aura of magic or whatever, the wind. How I see it, it is the magic that reacts and does all the things, moving the mountain, plus the wind and the clouds. Here, with the music, connecting it together and causing all this commotion. And then there is the dust devil and the village scene in the background and the coyote. [There is the] rattle and the basket that they use like a drum. The stick has these notches on there and you can put it on the basket and you can run [it back and forth] and it makes it like a rasp. The lady back there has another rattle. When they both sing, it has a harmony to it. It always has a different sound when the men and women sing. They add the background to the song that gives it a . . . all I can say is when you listen to it, you can tell that the men are the first ones that start and then the women pitch in later on.

This was just about as fast that I could create in a painting. There are some paintings that come out just like that because I can feel it . . . my own feeling in my heart about how it used to be. This one is like that, and you know, it came out fast, maybe three weeks or two weeks or something.

FIGURE 28. Untitled

And when I sent it to the book company, they looked at it and they thought I had put an eagle in the corner, but that was just a part of my painting that I did. It just came out that way. See the rest of the cloud [pointing to the right-hand side]. It kind of comes up like this. There's a little brown spot on the front they said looked like an eagle with the wings like that. I thought they meant this [on the left-hand side], and I said, "No, over here on the other side." That's what they were talking about.

There's another little short story [in the book]. The kids that belonged to the Kachina were playing along the creek, making mud pies. I think it says they are playing under the watchful eye of the Kachina. That's what I did. I put the Kachinas in the trees. I've seen paintings that people do that. They put the Kachinas in the trees. And now I wonder, "Where did they get that from?" [laughing] Not that I'm the only one thinking of that idea. In the back are the San Francisco Peaks. That's where they [the Kachinas] live and where they come out according to the Hopis. When they come out you can see them coming down San Francisco Peaks. There's a salamander [in that picture]. [laughing] I try to think of the things that are in the wet spots, in those areas. It's pretty moist up there. The way I made this one, I was using dots and x's and lines because I was pressed by the deadline when I was supposed to have handed it in. So I had to do them real fast and so that's how the x's and the lines came in and some dots. Because I had to do it in a hurry.

Some of them are from the time when I'm thinking of something mystical or just in the thought, that's what happened here. I guess I see it as real. It is the way it is. You can't put your hand on it. It's out there and it's only for that person. Nobody else can live it or see it. It is only for one person. You can't get into the specifics; it's real. However you take it, then that's how you use it. It gives you that energy. I saw this as crucial to use this healing, more like saving the life of somebody or healing them.

It's passed on down the line to whoever gets it in the family. I guess that one day when they appear in the family where you become a medicine man if you want to take that part, they usually send you out for a certain amount of days in the desert where you fast and see your vision and during that time they have, they say the animal that shows up that's the animal that will assist you in your time as a medicine man, you know, giving information.

SUSAN LOBO: Leonard speaks here of his art that depicts becoming a medicine person.

The young medicine man, they send them out there to get ready to combine themselves with somebody or something to work with for the rest of their life. They always say that you go out by yourself in the desert and you find your song and you find your partner. They give you something to use and you start out with a feather. Then you know your visions and things that you can do later on. You think back. Maybe your grandfather or maybe your dad did it and you follow in his footsteps. And you get your first feather. And that's when I did this one (fig. 29). I stay away from some of the major things that also goes on at the same

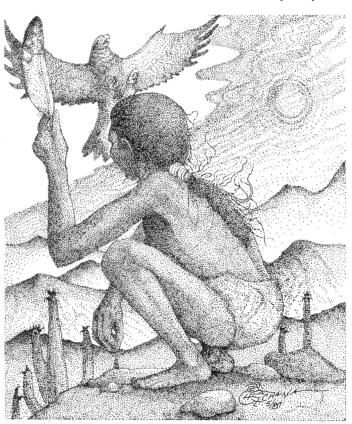

FIGURE 29. *Young Medicine Man, Hegal Wechlj Oodham Mod Mah Jal*

time. This is just a glimpse of him being in the desert and getting his first feather.

It's just what was in my mind and my heart. At the time I was missing a lot of things that don't happen anymore, and one of them was this. I guess they do it, but it's not so much the same way they used to.

Some of the stuff that I was starting to do, I felt that maybe I shouldn't do. [laughing] That's why I stay away from . . . I'll do something up to a point and then I get into the deep meaning of it and I stop right there, because it's just for people who believe in it and follow the tradition. That's only for the people that are taking part. Whatever their belief, I don't go into that. It's kind of skip-over stuff and not try to do things that they might not like.

It's kind of hard to really do this, because I know there is a limit to it. I wouldn't share it much with anybody.

My grandfather told [my dad], "If you do it, your life is no longer yours. If you take this profession, you will always, day and night, you are always going to have to do it." They are giving their life away to the healing. With this, you have to be available to take it on totally, without looking at anything else. It's having faith in what you're doing and not doing nothing wrong with it.

I don't know where the image came from, just something I wanted to do (fig. 30). This one was coming out, it's one of the little groundhogs. We call them *chehkul*. They stand up like that. Here the snake caught him and the eagle came to eat the snake, so he had to let him

go. The medicine man was also there and his spirit brought the eagle to rescue him. He got saved and he [the snake] got eaten. And the eagle got food.

I was sitting there working on [a similar] one and my stepson came in with his friend. The friend stopped and he was looking at it and said, "Do you think you can make me one like that and I can buy it from you?" I think they were sixteen or seventeen. So the next time he came, I had finished it so I gave it to him. And he said, "How much?" I told him, "O.K., you can have it." He said, "No, I'd rather pay for it, you know, because I like it a lot and I love art." I told him "$20, I guess," so he took that original. You know it was kind of . . . I don't know what to say, funny, because he was young, but he liked it and he wanted to pay for it and own it. So I always remember that.

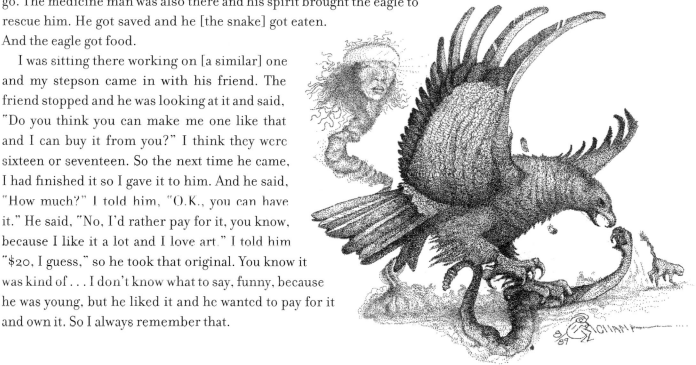

FIGURE 30. Untitled

Some of the Things She Wrote about I Remember

The first time I met Byrd Baylor we were doing a show at Continental, Arizona, and the second time I saw her, I shook her hand and stuff, but she never said anything. It was Mark [Bahti] who came over and said she would like for me to do the illustrations for a book called *Yes Is Better than No*.

They were doing a third edition on it, and she wanted me to do the illustrations. I had read it, or saw it, back in '72. I didn't like it then, but Mark said I could see what it is. Then when they brought the book over I started to read it, and I remembered that that was the one from way back. So I just put it aside and I didn't read it for about six months, I think. And that's when they were asking me, "Did you read it? What did you think?" I said, "I'm not finished with it yet." [laughing]

When I first read that, like I said, I didn't like it because of the way it started out. I had picked it up even before, maybe in '71 or '72, at the library, and I started to read it then, but I didn't have any real time to read the whole book. I just started to, and when I did that, it kind of got me because of the way she started out, talking about the women and stuff. I felt uncomfortable with it because it was too close to the way we O'odham live, and I felt like we were being made fun of. But I never got past the first chapter. I just put it away and didn't read it. I felt uncomfortable, uneasy. And I didn't like it then either, because they had a Navajo sitting in front of the book, on the cover.

They had Navajos [depicted] in there, wearing silver and stuff. So

when I started to read it, I didn't like it because there was no relation to O'odham in there. So I thought, "Just some white woman writing about the Indians." [laughing] So I didn't really read it.

I didn't read it again. I just put it . . . I didn't even know where the book was. A month later, or like three months later, he [Mark] called again. "Did you read it yet?" "Oh, I'm not finished with it yet." [laughing] "I'm busy."

So it was getting close to when she needed to find out. "So, if you can't do it, they'll find somebody else to do it."

O.K., so I slowly read it, but when I got past that chapter, and after I got past my own, what it is, you know, not liking the people, the person who wrote the book. I was being prejudiced or something. Then all these things she wrote about, which were true because that's what happened, it brought me right into the book. I couldn't even see anything around, just what it took me back to in my mind, when I was little, my childhood. It was true.

Later when I got past the first chapter and started reading, everything started to fall in there. It opened up my emotions and feelings, my tastes and smells, everything. I couldn't help but say "yes" after that. [laughing] Some of the things she wrote about I remember myself, when I was eight or nine, or maybe seven, and we were living in the cotton fields, and my mom and dad would come home that evening, and they would be talking at the dinner table about what happened over the weekend or last night or something and some of it is in there. Byrd Baylor talked to one of the ladies that lived in the same [cotton pickers'] camp and that kind of drew me in and I felt really comfortable, like a warm feeling.

Byrd Baylor goes and is in the middle of things. She remembers what they talk about and writes it down and puts it, so that part of the book, that's true, you know. I could tell where she added her own writing in there and where I really remember. Like the crazy lady they used to talk about her and stuff. I think they called her Tukee Laura or something like that. She was always drinking and stuff. They always call them *pi wehsig*. All that I know from that is that she gets drunk, and I guess there was nobody else in the family that was drinking, so she would get drunk and wander around.

Sometimes when I think of things, it seems to be a dream or something, so when I read that in the book it just brought it back to reality, the way I was thinking. I thought maybe I was just a young kid and

SUSAN LOBO: Quote from Caroline Antone from T.V. interview with Leonard: "It's incredible . . . about the families and how we were raised. It's more like a memory book, and that's what really makes me feel good when I look at your pictures. There's one about a truck and the kids are in the back and grandpa and mom and dad in the front. And I could see . . . you drew me and my cousin and my other cousins and I love that picture.

A friend of mine gave me one and I've kept it for a long time because I lived in the city a lot and I rarely go back home. But when I do go back home, I love that picture. It's so homey; I connected to it. [Going] back in the truck . . . back in the day, I guess. Just to look at it, you can almost just see Home from there."

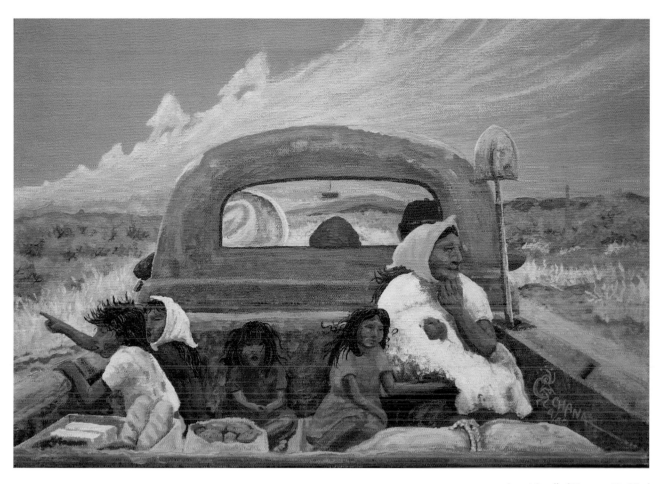

FIGURE 31. *Sweet Smell of Home on My Mind*

just had that dream, but I read about it and it brought it back like, "Oh, yeah, I remember certain things," but that is a lot to really remember in O'odham . . . things that went on, but I know the lady that Byrd talked to where she got most of the information.

I think about the way when we came home from the cotton fields and everything's over and we'd go home riding in the back of the truck . . . at that time what it felt like, and what the area looked like (fig. 31). It brought back all the smells, how the food used to taste. So it was special in my heart when I did those for that book, the illustrations. As we're driving up, all the trees, the old road that takes us up to the house, where we come out of the trees, you can see the adobe house. It's always so vivid in my mind and how I felt, because it was so different from where we were [at the cotton camp]. It was just like I was right in it. I put myself in the way it was in reading the book. It was fun, getting back there. But since I took so long, when they asked me again if I

had read it, I said, "Yeah, I guess I'll do it." And he says, "Well, you've got one week."

Actually it was maybe three weeks or something that she would like the cover to be done in color, so that's what took most of my time, to do the front and the back cover. Then inside, "You've got one week to do that." And there are like twenty-one [illustrations]. Because I could see the people, just what I see in my mind, so . . . it was a trial to do it in that short of a time, but I felt good about it. Because I could see, it reminded me of the days.

It was so clear, the stuff we used to eat, and how it smelled like when the rains came and you could smell the creosote [bushes]. That's what captured my heart, you know. That's what brought in the picture on the back of the book: the people in the truck. That's what I was thinking of because like I say, I remember when we'd go home from the cotton fields, how when we're driving you can smell the different smells from the trees, the area, and even from the first night, and then that morning when Mom fixed the breakfast. Even the next day, the lunch, and when it rains, it all comes together. And that's why I did that picture, because I remember sitting in the back of the truck, only the truck is a little bit bigger and it's got boards on the side. This one I just did a smaller truck.

The book is mainly on how the O'odham way is and what they were finding out living in Tucson—how they found their rules and regulations. They were just finding out the main things they have to deal with: the social worker, and the people that work for the social worker, and finally the police officer who has to enforce the rules and the regulations, because they wouldn't follow it. They lived the way they lived on the reservation and every now and then they would have a visit from the social worker to see how things are. That's how I did this (fig. 32), because every time she shows up they would say, "The dust devil is here again." Because she's like a circle and talks about this and that, and what not to do, and what you are doing wrong, and these are the new rules and regulations, and leave papers off and stuff. They would laugh and say, "The dust devil came again" and took her off. Then when they show up, they would make sure they were at her neighbor's house. Since they don't have a place to stay, they would stay at her house, but it was only supposed to be her [neighbor] living there. So they would do different things to change it whenever she [the social worker] shows up, the names of the kids that she has.

What they are used to eating is the natural stuff like the mesquite beans and the fruit off the prickly pears, and the utensils that they used which is the stone grinders and the baskets. And then later on they had the government rations [surplus commodities] like flour and canned goods and stuff. And that's what this is. They always sat on the ground or slept on the ground, so I put them on the ground [in this picture].

And you never think about the dirt on the ground. But I remember that, lying on the ground and when there is nothing to lie on, just the ground itself. Once in a while we kind of would wear shoes, but then, my mom never really understood that. And then your soles [of your feet] get real thick so you can't even feel it unless it pokes you real hard. I remember that even in the hot sun like that it would be O.K. for a little bit until you've been out there for too long. Then you begin to feel the heat. For me it was always strange to see somebody with shoes on when you go play, especially in a real soft area; we'd be running around and see somebody with shoes on and they would have to take them off.

I wanted to show the kids that were close to me and the oldest one was always taking care of them, the baby, and the one in-between was like caught in between and not really knowing what to do or that every-body else has their position.

And then when those Indians showed up with ties and stuff, passed around papers too. I guess it's like asking them to join them to see what the white people are doing, trying to do, and you don't have to do what they are asking you to do. That's what he's doing with these papers. And she [the woman in the picture] just had a baby. . . . She's from the reservation and came out to Tucson, I guess to work or find out what she can do. That's why she moved into her neighbor's house, because they didn't have a house. That's why these guys come in [to Tucson]. And here are more papers with more regulations. When she was making baskets at the county fair, she would drink Barq's soda, red pop. My baking teacher [at Sherman Indian Institute boarding school] always said "Indian red pop." Strawberry. This is the shrine they are always talking about in the book, and that's Tucson in the background, and that's "A" Mountain in the back.

One thing that I didn't put in there was the pool that she won [in a chapter in the book *Yes Is Better than No*]. It just didn't sound like something they would do.

[The woman with the red scarf], she's whispering that "here comes the dust devil." Hewel o'oks, which is the wind lady, or what I always

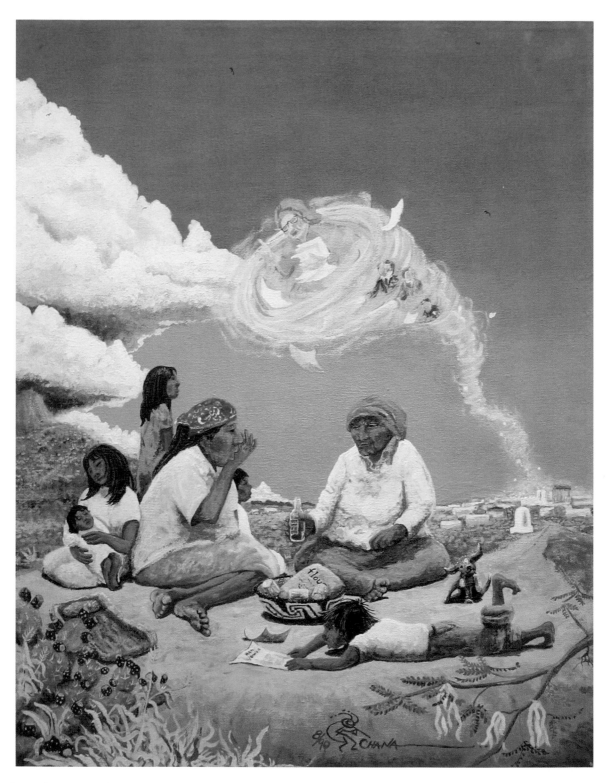

FIGURE 32. Cover of *Yes Is Better than No*

hear from my mom or my aunt was Hewel o'oks. I remember a tall woman with grayish hair and she would come over and we'd all go inside the house and she'd come and knock on the door. And we'd open it up, but only once she came in; but the rest of the time, it seems like she was always outside. And then she'd hand that paper to my mom, or some papers with all these words on there, no pictures, forget it.

The people I remember are the social worker and the Mormons. They would show up and also reminded us. They would show up and talk about God and stuff and leave the pamphlets or something that we could read. I never read them. They'd just lie there and end up in the trash, or Mom would use it to start a fire. Not that many [Mormon converts on the reservation] at that time, but I don't know about now. You always hear horror stories about them guys. I guess they would take the kids to live with them in Utah, and I guess that's what they taught them. I guess they went to school. I always hear different things about it. That's as far as I knew back then.

[When I was young] nobody really accepted the religions. The only other one that was active were the Baptists or the Protestants. But they always say *mimsh*. This is the Presbyterians. The church that's in Sells now is the Presbyterian church. That's always where they say they went to do their camp meetings and stuff. There was a big split-up when they first came; they first built the Presbyterian church. There were certain groups that were real strong in the Catholic [Church], and they were always doing things that needed to be done, like certain ceremonies or celebrations for saints or the church name. They were there to start the setup for the cooking and the celebration, the dance and all that. But when the Presbyterian church was built, it split up the strongest of the Catholic group. It made a big split and a big hassle. They were mad at them and were calling them names and stuff.

They brought down a lot of the Catholic Church. It was never the same. There were still groups that came up and took their position, but they never did it the old way, when they were all together. A long time ago, that [the Sonoran Catholic belief] was the only thing until the Catholic Church came in. It was just the small little house with the cross in front, and the people who were the leaders in the village; the community would do the whole thing. But there are some that's come in from the other side [from the Mexican side of the border] because a long time ago they didn't have the border. Whenever they had a special day, all kinds of things would happen: the food, the dances . . . The

SUSAN LOBO: Here Leonard begins to tell about the organized religions he remembered from his youth while living on the reservation.

FIGURE 33. Waila dance at Santa Rosa.
Marie R. Chana photographic collection.

(below) FIGURE 34. *Waila Dreams*

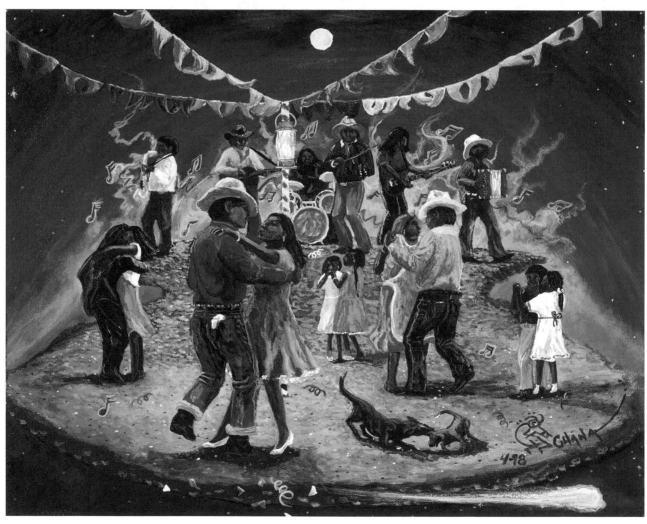

church would be decorated, and people from all over would show up, so many people, and all helping and all doing cooking or setting up the tables for people to come in and eat. And the dancers and musicians; sometimes they'd have two or three of them. They'd do a song they want, and all the dancing would start until they would say, "No more, it's time to go home and go to sleep." But I always looked forward to the main things when they had them, because everybody would come together and do it from the other villages. But once it split up, they went down.

They used to have a women's club that would make tortillas and tamales and what they call *poshol*—it's menudo a special way. They would sell it to make money for whatever they need to do at the church, plus the women's club, whatever they needed. You know, everything was good, just the taste of the food, and all the best cooks were all in the club. It was good. But once that happened [the other churches coming in], it just all fell apart. The main thing that really stayed was the food. They were certain when they have the ceremony, the dance, they have the food all night until in the morning when everything ran out.

Even the Sonoran Catholics, now they are separate. They used to come all . . . everybody came to do this ceremony, this celebration or whatever. But now they have their own little group over there and they are always the best groups too. [laughing] Well, at the village of Santa Rosa they [the Sonoran Catholics] have their own little church where the priest never goes to the Mass. It was always the women who say the rosary. They would spend more time saying the rosary in Spanish. They would always go to Magdalena [in Mexico] when they have the [St. Francis pilgrimage]. They did everything on their own, and they had women who could do the Mass in Spanish. If they did, they would rather have the Spanish or the Mexican priest because they never had the priest. It was the women who did the whole thing. There's one that leads the rest of them, a group of women.

I know that's where my aunt Molly used to be. They set the time and what needs to be done with the church and the food. Their husbands would do the other stuff like repairing the building, the kitchen, the dining, and the dance floor for the musicians, and the building of the church. While the women did the decorations and what kind of saints, the pictures, and how they put in the flowers. The men would do the outside stuff, and when it's time, the women would do the Mass or pray, and they would take the saints out for a procession. They used

FIGURE 35. Untitled

to have a little cross that they would go to and say the rosary again in Spanish. They'd sing [walking the cross] and they'd sing coming back. Once they got through, they would have these big boxes of candy and sweet bread and they would pass it out. Everybody would take their own paper sacks to make sure . . . [laughing]

Also, they'd get down. It was usually dark. They'd usually start when there was no electricity. When they came back, they'd set up the musicians and they'd start playing right away, and they'd dance right there in front of the church. And once the sun went down, that was it. You never saw a drunk, or if they did, they'd share. That was one of the things they did, pass around either tequila or somebody made hooch, which is raisin jack, and that's what they would pass around. When the sun went down, some people went home. But at the big church they had the big band. There was more stuff and more people that came. When the sun went down, they would use the lanterns in the middle. And they would dance up until morning and then they quit. At the other one, at the little one, they usually quit when the sun went down. Sometimes they'd go a little bit longer if they had more money.

Sherman

hen from that, kids started going [to boarding schools], and that changed the whole thing about learning your culture and ceremonies, because right in that time it is the prime time they teach them. You know, they teach them when you are little. If you don't listen to your Elders, something's going to happen to you if you run wild and don't respect their telling you what not to do. You see how your brothers and sisters are going, so we follow them, and learn from them, and also from the Elders. When they get to the teens, then they are taking part. It just depends if you are a quick learner; that's how they move you along. If you understand it and live it, what they teach you, then you move up in the ceremonial dances, your position. In the traditions, you take part in the meetings. The Elders start out with the ceremonies that you should have, that you should get ready, maybe two months before. They start them out, teaching them about the ceremonies—learning and growing and respecting what you need to, and do it at the time when you pray. Whatever the ceremony is, you have the right mind and stuff. When the ceremonies come around, they know what to do and are learning more about life in that time. But when they

FIGURE 36. Untitled

started taking them to boarding schools, they took them out of that position.

You don't take part anymore, and you start forgetting what it's supposed to be, the real reasons for doing the ceremonies, why they want you to take part. A lot of the ceremonies they quit because the kids no longer respect what they are doing and no longer respect the Elders. It just got worse with the wine, well, actually the alcohol on top of everything. Their way of thinking, all because they had to go to [Indian boarding] school. A lot of things you learn there are bad.

You come home and you start influencing the younger people because they are looking up to their brothers and sisters, what they are doing. Sometimes they get worse because what your brother did. Because I remember my brothers were . . . by the time I was growing up, they had come out of their rebellion, but there was still a little bit of that. So that's what I followed. But because I followed them, I made it worse because I wanted to stick out, just like they were at their time. I had nobody else that I could share or be with, so a lot of things that I did, I stepped it up more. I was pretty bad, you know. But I figured, "Well, but I completed my mission of sticking out and being real bad."

I didn't even know that [being creative]. I was nowhere near. In my teens I went to Sherman Indian High School in Riverside, California. In the evenings they would have art; if you want to go down there, you could, in the basement. I had a chance to go. They had all the tools. I used to draw football players. They'd throw a pass and this guy jumps up. I'd do it in the position when he jumps up and when he falls down. In the other one, he gets tackled. I'd do all these different steps. Yeah, and you could paint and do whatever you want. We'd go down there, pick up the girls and leave. [laughing] I was pretty bad, but at the time I was being proud of it, because I was actually growing up. At least that's what I thought. I kept it up more, and it made me feel that I'm more grown than they are. That I can do better on the worst things that they did. I was pretty bad.

Sherman was an institute the first year I went. But then the second year a group of students took part in changing the name from Sherman Indian Institute to Sherman Indian High School. We all worked on changing the name from institute to high school. Then the second year, the classes became curriculum for high school and all the other stuff. When you called it an institute that's like you learn a trade. But

they were changing all that to make it a high school. That took a while too, to do that, to write to the government in Washington, D.C., to get what we wanted.

They used to have Mr. Henassey: he was the baking teacher. He was Comanche from around Oklahoma. He used to talk to us about not letting our land go or cutting it up, because what he saw in Oklahoma and other places and what happened to them. He put a lot of stuff in my mind and in my heart on how to look at the Indian and the land, and how people try to take the land. They can do it, because they divide it up, but the Indian groups who live there, it is up to them to take care of their land. A lot of them were selling it because they didn't have money, or they wanted to have money, so they were selling their allotments. You know they were cutting it up, the reservation. What he saw, he learned. So he said, "Don't ever do that. If you do that, they'll take over once they take your allotment." So he was the one who taught us to do that—to change the high school name. I just happened to go over there and hang out with them, and I got involved with them. I didn't know a lot of things, but that's something of what he would tell us. Then from that I wanted to find out more what's going on. A lot of it wasn't good, what I heard from him. But also he told how you can handle it, so it doesn't go into losing your land.

We had to be there, at Sherman, nine months out of the year. We couldn't come home or anything. They were told that they didn't have money to send us home. But other boarding schools like Phoenix and St. John's [Indian School in Laveen on the Gila River Reservation] schools, they sent their students home Christmas, and they let you go home if there is something going on at your community that you want to be a part of. At Sherman, they never did that; they just kind of kept us out for nine months out of the year. Finally, at the end, when I was a senior, they said they had enough money to send everybody home that wants to go for Christmas. So they did that, but the rest of the students that didn't go home, they asked us if we wanted to go with a family to stay with them over the Christmas week. I decided I'd like to go try that with a family. They came and picked me up. It was up in the foothills, real nice house, and they had three or four kids: two of them were older, the girl and the boy. The one boy was, well my age or maybe younger. At that time I was eighteen. You know, he showed me around, what he did and stuff. But what I liked was he had a little moped or lit-

tle bike and Riverside is just rolling hills. We rode that bike. He taught me how to ride that bike. It was fun, but it broke down and I couldn't do it anymore. [laughing] It was already old anyway so . . .

And we'd hang out at their garage. They had a garage where they fixed stuff . . . tools. And they had a sheep, a big old ram that we could play with it. It wasn't mean or anything, it would just playfully butt you around.

I remember that the girl came back from San Francisco. I guess she was hanging out up there where the hippies are. I think she came by with her boyfriend, and I guess he lived there too. He dropped her off. We went to all these places . . . restaurants.

One time we went up to Knott's Berry Farm. Every year at the beginning of school, they put up some papers, one was Disneyland and one was Knott's Berry Farm. They had twenty spaces, so when it came we could sign our name. So every year, we'd go in the beginning, and then they'd put it up again in January and we'd sign it and go again. We went to Knott's Berry Farm twice every year.

If we had a job, we could stay there [at the school] through the whole year. At the end of the school, you could just start working and stay at the school. They are always saying, "Are you sure you want to go?" But if you mess up, or get drunk, or run off with your girlfriend, then they send you back home right away. It just ends like that. Some of them, they give them a second chance and they'll come back the following year, but some they just come back during the school year. If they ran away from the school, or get drunk, or be in trouble all the time, or do something real serious, they won't come back.

It is open and you can leave in the day, but you have to have a pass that says you are out there, that you have permission if you are out there running around. They say that you had to stay on the main street which is Magnolia, running all the way from Riverside and all the way to Arlington, and past, going out that way. At the time the houses had only been up maybe a mile from Sherman. So they told us to stay on that street, "Don't go anywhere else; don't bother anybody." [laughing] So of course we didn't stay on the main street; we were out running around in other areas. [laughing] They had the Mexicans living about a mile away on the other side of the freeway; that's how they cut the block up. So we used to go over there and have them buy our booze for us.

So it was kind of hectic, but I wasn't . . . for some reason, they never sent me home. Oh, I always did something, especially at the beginning, when I first went. I guess I was testing all of them. [laughing] But usually they would send some of my friends home, the ones that we did different things with, but never sent me home. I was always wondering why, even at the time when eight of us ran away from the school.

We were probably about fifteen then. We stayed out there for a week. There were four O'odham, three Pimas, and one Apache. When we first started there was just three guys that were getting ready to take off. I was just lying there and looking at them and they tried to run out. They went out and then they came back in and said there were too many guards hanging out. Then they came in to go to bed. That's when I decided, "Well, I'll go with them." I got up and grabbed a blanket, and we took off and went down there and started hiding from the school guards. Then pretty soon the guy stopped and we started running and we got across. He stopped and said ["Who's there?"]. Nobody said anything—we just stood there. And then he didn't come over, he just walked off. So we went and climbed over the fence, went over the chain link and got on the tracks and started walking.

We thought it was late, maybe 10:00 or 11:00, so we waited until morning. We tried to lie down and we only had two blankets, the one that I got and somebody else had another one. So we all shared . . . four under one. This was probably November. It was really cold, man. We decided to build a fire, and we built a big fire and the cops showed up. We could see the cop cars coming out, the lights, and we were kind of in the middle, so they couldn't come right up to us. We all took off in all directions.

Yeah, that was a pasture where we went because there were three of us who took off this way and a little higher up there we were watching the cops come. They went down to where the fire was. They put it out. We wondered if those other guys got picked up or anything, because we all took off in all directions. We just stayed out there all night. Man, it was cold. We got cramps and shivering and I couldn't lie down. One guy lay down and the ground was all wet. He was lying there sleeping, but he was wet. It was cold. I didn't lie down to sleep all that time. Then the sun came up. It was a lot better, so we started making our way back to the place where we had the fire. When we got there, everybody else started coming back. [laughing] So I guess nobody got caught. And

they said, "No, well, let's go eat breakfast," so we went and got oranges. There were a lot of groves around there. Then we climbed up another hill there and slept up there during the day for a little while. That's when we crossed the freeway and we climbed up to where we were. But that kind of stuff just continued on from that morning. We were going home, but we ended up just about six or seven miles from Riverside, in Arlington. We ended up just hanging around in that area, just messing around.

This guy knew somebody that had done that before. He walked to, I think it's close to San Bernadino. There is a place where the train is coming and they stop to do something, and they go on from there. They said the guys went up there and found out which train goes to Arizona, and they got on the train and that's how they rode back to Arizona. So we were thinking of doing that and we started walking, but we ended up in the foothills, and we climbed up there. We would sleep up there, and then come down, and we'd go in there to the supermarket and take food. They never caught us or anything like that. Then we'd climb back up and eat the food and stuff. It was kind of like a neighborhood area. One time we saw this van, it's like a jeep van, and there were a bunch of blankets in there so we took those. They had their windows open and stuff. Then I guess the people around there in the hills noticed that, and one morning when we got up, we went up to the top of the hill and looking down at these people and stuff, and they were looking up and pointing their fingers. [laughing] And we were there acting crazy, you know. We looked around, and sure enough there was a cop car coming around. And we looked around and, "Oh, no look, there's another one other there." They started driving on that little hill. We took off down the hill.

Finally they stopped below and they started coming up, and we took off the other way. There was a big house, an old one. There was this old lady who came out and said, "Stop, stop." We were going through her yard. There was a hole in the fence, and we came out on the other side. So we ran into the orange grove, and the cops surrounded the grove, and they pulled us out one by one. This one guy started to get rowdy with them, and I guess they were mad because the cop fell down and tore his pants. [laughing] But they got us all handcuffed and took us in the squad car and took us downtown. I guess they looked up the crimes that went on when we were out there in that area, mainly the

breaking into homes. We never broke in. The car, that was the only one, for the blankets. They said we broke into a house and took all the food out of the refrigerator, and took some money from somewhere else, and broke the window, and did some other things. Anyway, they pinned all that on us, and they divided us up, but for some reason, all the O'odham, they took back to Sherman. The Apache came with us. The Pimas they threw into juvenile hall. For some reason that's just the way it went. They were in there for a week, and then they came back out. One of them was sent back home right away.

They [the school staff] took us all back, and they told us to grab some clean clothes and nobody had any clean clothes. And they told us, "Grab your dirty clothes," and we all grabbed them and they took us to the Laundromat, and we washed our clothes and went back, and they marched us down to the showers and we had to take a shower. Then they put us on extra duty. You had to do cleanup work.

After I graduated and all and came home, one day I was looking for some of my stuff from school and I came across the papers that they sent to my mom. That's what they said, certain things about what I was doing, that they were considering sending me home. She would write back and tell them not to do that because, I guess, "He didn't know any better," and I was a follower and stuff [laughing], so they kept me. My mom had already gone through it with my brothers.

Because all that time before running away when they would catch us, they were giving us extra duties. At one point they would ask me to exercise, sit-ups and push-ups and running in place and all that, I guess for two hours every night. And we would do it right where the door is in the evenings where everybody meets their girlfriends. They're out there hanging out, and we were out there, right there. At one point the guy that's the boys' guidance [counselor] got really angry, and he told us, right in his office, to get down and start exercising, "Push-ups, do fifty push-ups." So we were doing it, and one of my friends, the Pima guy, couldn't do it. And the counselor was really mad, and he took a big old stick like a yardstick and he whacked him on the back. It broke and he started crying, and then they made us stop. They were saying that he was worse before I got there. They didn't like him. I did hear that it was really bad for a while there.

They had different punishments along the way because when I got there they were just finishing the vocational school, and like I said,

they were changing into the high school. They would lock you up in the basement if you really did something bad, or even talk back in Indian, or cuss them out or whatever. They'd make you eat soap, and when you eat food, you can taste it for about two weeks to a month. Government soap. [laughing] It was the stuff that they issue, big giant soap. You know, your lips get all swollen, and you can't eat too much until all that taste goes away and your stomach gets better. I guess they told them not to do that anymore, but that guy couldn't hold himself back when he hit my friend on the back with that big ruler. If we can take it, we can dish it out too, eh? We just didn't say anything. I think eventually he [that boy's superintendent] got older. I saw him after I graduated. About six years after that I ended up at the University of Arizona. I was going to school there, and I saw that guy there, all white hair, almost the same except for the white hair. But I didn't go up to talk to him. I just saw him from a distance. I kept walking by to make sure it was him. He was a tall Indian guy, crew cut. I didn't talk to him, but I kind of just made sure that what I'm seeing is real. I think he was either going to school, or he was doing something there. They were saying that he was worse, before I got there. They didn't like him.

But that's when things were changing, and they were putting more Indians in positions in control, power I guess. In the dormitories, most of them are Indians, taking care of things, keeping the kids in control. But there's a few whites who probably have a little bit of Indian somewhere in them, I'm not sure. At first I was thinking that they were white, until later on I found out when they started putting them in the yearbook and started naming their tribes. I found out the people who worked there were Indian. Some of my classmates took over jobs there and were working once they graduated.

SUSAN LOBO: Leonard continues to tell about his experiences after they ran away from the school.

They were talking to us, and so the next time, the next week, we got into trouble again. You know, of course they didn't like it. That's when they brought us in, and we were wondering, "What are they going to do to us?" So after that, after we ran away, they brought us back and everybody was back to school. They called all of us in, seven actually, because the other guy got sent home. They told us that they were starting a new program to keep the kids in line where they would try to work with kids that were more, you know, disrupting and stuff. That they were going to do a different thing, "instead of the stuff we'd been doing, you know, beating you up." [laughing] It was a different person that talked to us.

He was a nice guy. They are all Indians; they get those guys from somewhere. I don't even know which tribes, but this one guy, this nice guy, was a chubby little man with glasses and a crew cut. He was talking to us, and he said, "We are going to keep you busy on weekends. We'll do different things. Whatever you want to do, just let me know and we'll set it up for the weekend." So they would take us to some places like a lake and anywhere we wanted to go.

Then they took us out of the dormitory we were at. They separated us to stay in like the older boys' dormitory. They sent us off to the dormitories, so we had no communication except at school. We did that all the rest of the year. One guy, I guess he wet the bed at night, and his brother happened to be working with the older high school guys, so they put him there, so his brother would come and wake him up to go to the restroom. They put another guy there who was from the other end of the dormitory. It seemed to kind of quiet everything down, and it was like that for the rest of the year. This was actually the first year. Only half of my friends came back the second year, because they wouldn't let them come back. So that was kind of what we did.

But I really didn't want to come home; I was just interested in what was going on. I was curious. Also, I wanted to do stuff. [laughing] But then I came home and I find out that it was my mom who was telling them to keep me there or something. Especially my mom—they wanted us to go to school.

One [brother] went to St. John's and the other one went to Phoenix [Indian School]. One of them, the oldest one, did try to go to Sherman, but he got thrown out for some reason. I guess he was doing something. But I always liked Sherman. Like I said, I liked being with all the kids and stuff. I enjoyed finding out about the different tribes and meeting all the different kids. They all had different thoughts and things that they shared from their villages.

[laughing] I don't know why other people don't [like boarding school]. Maybe I had heard so much from my mom about school because my older siblings, my sister, didn't come back home after; summers, they'd stay and work. And one of the things Mom said was "[your sister] doesn't want to come home because there's a lot of work there and they've been through that and they don't want to go back to it. They work where they can make money." That was their reason for not coming home [where] they have to do the labor, to get the water or

wood. That's the main thing. You had to go get water at the community faucet. You have to keep it up. You have to go get wood, bring it back, chop it up, bring it into the house. And of course light it up, getting up early in the morning and [lighting it again] in the afternoon. You know there are three meals a day. Sometimes when I'm out, you have something to eat in the afternoon, but we always expect a supper in the evening. You know, it's what the family wants. It's more work than what you do in school. You learn how easy life can be. The water's there; you don't have to go get it. You don't have to do some real hard work with your hands. That is why they don't want to come back. Because my dad was always plowing and working hard in the fields. They used to see him all day with the wagon. Sometimes I'd go with him and hang out when he's going back and forth. It's a lot of work. Some of them didn't want to come back for that.

I know my friend who is younger, maybe he's a year younger. We went to Sherman. He was one of the ones that we took off with [ran away with] and did all kinds of stuff. The second year they sent him home. We kind of grew up together. We're different villages so we didn't see each other that much, except in school. I first met him in Santa Rosa [Day and Boarding School] and we ended up in Sherman together. Now, every now and then I'll see him. His kidney got messed up, so they took it out and him and his brother did dialysis. They didn't have it at the time at Sells. He went for like for almost ten years. They finally found a kidney for him, and he received it, and they were watching him to make sure it works. And finally it worked out, but he didn't care, you know. He was a bad dude, I guess. [laughing] He started drinking again, and he was all right until he got into a fight. His son did something with another guy on Tucson's Southside and they started fighting. A bunch of them jumped on the son. He got away and ran back to tell his dad about it, and he came over and started fighting with them. They knocked him down, and they took a boulder, a rock, and mashed it on his chest and he died from that. But his kidney was still in there.

[The other kids I ran with], we see each other now and then. One of them got killed over at Why [a place just west of the Tohono O'odham reservation where two highways come together]. Guess they were coming back after they closed [the bar]. Him and his brother each had a car, so this guy, he went first, and then his brother went after him. They were all going home, back to the rez, and on the way he lost

control of his car and flipped it. He was still alive. He got out of there and he crawled to stop traffic, I guess. He got on the highway, and his brother didn't see him and ran over him. Yeah, he had just graduated like two years, or a year before. His older brother also graduated from Sherman. I did hear that it was really bad for a while there.

I don't know about the other guys, where the Apache is. He was a big guy, bigger than the others.

FIGURE 38. Untitled

Working with My Dad

W hen I came back from graduating, he felt that I was old enough that I could help. But I'd rather run around and cause trouble. When I came back, the Elders that I used to learn from were gone. My mom was working at the boarding school at Santa Rosa as a cook, and my dad had picked up his own business of selling stuff out of his truck. He would drive to different villages, and then the following week, he'd start all over again. Sometimes he wouldn't make it to all of them. Then he'd wait until the following week to go to them on a different route.

There is one [artwork] that I did a couple of years ago that was a big tree with this person who sells produce and different food and stuff to the people (fig. 38). He would go in the wagon and pick up the stuff that he's going to sell, and he'd go back to each village, and he'd stay for a couple of days and sell to the people who would come around. He would be trying to find a special tree and park under there, and the people would come. The people didn't have any money, so they'd bring chickens and trade for that. The tree was more extended, so I spent a lot of time, trying to make it a certain way. That was interesting.

He started with that when I was eight or nine. But things started changing in the sixties. That's when he actually bought a truck, just to sell. Before that he used to just sell at home. There would be a line of people. They would come over and buy stuff anytime, twenty-four hours. At night somebody'd be knocking on the door, wanting to buy

cigarettes. I wouldn't let them in. But during the day, we'd leave the door open and they would come in. You'd see them coming, so you are already waiting and tell them, "Come in," and they could come in. They wanted the bottled soda. And then when drunks come over, they don't have no sense of respect for anybody, for you or for close relatives. They just create trouble with somebody. They drive away the customers. To take care of that problem, he quit selling. He was giving everybody credit who didn't have any money.

There used to be a store there of my mom's relatives. That's where he got the idea of doing it because they made their house into a store. When we went to church, they'd take me over there and get a soda for ten cents for a bottle. That's where he got his idea and started doing it.

He quit doing the planting and stuff like that because when the car came that took his energy because you could move around faster. A lot of things changed when electricity and water came. They had quit hauling water because water was brought to our house. The horses that we had, we gave them away, and some of them we sold. We could use the truck and the car to get around.

It got to a point where he tried to do what he had done earlier. He'd go to the cotton fields, where they would chop cotton. But there were

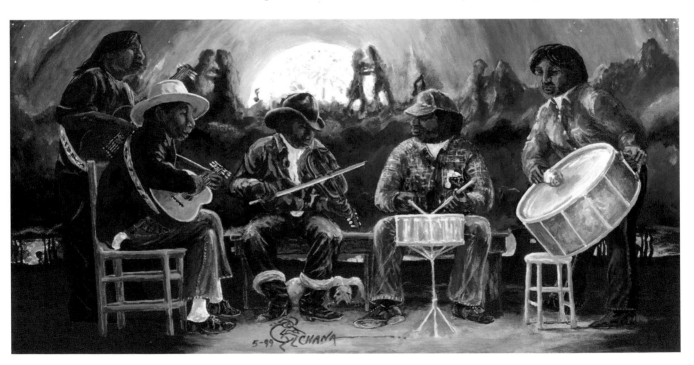

FIGURE 39. *Memory of the Music*

no jobs there. So he let people know if they still want to do that he would drive them. But that means that you have to get up early in the morning to get there by six o'clock to work all day, and then come back late at night, drop everybody off, come home, eat, and go to sleep. And early the next morning, get up and go again, pick up everybody, and try to do what they used to do. It was long. Back then it was a dirt road, so it took them about an hour or hour and a half to get where they were going. Then coming back, somebody would want to stop in town, and next thing that you know, some of them head for the bars right away, so it's hard to get them out of the bars to go back home. And tomorrow we'll be back again. He finally quit, and he started selling different things like food out of his truck.

He would get beer or wine. The districts vote on whether it is dry or wet. If you are a dry district, then you can have a fiesta, a celebration, but you have to quit at one o'clock. The wet district goes all night. They dance all night like they used to all over the reservation. 'Til it got bad. He got an old Coke machine, and the only way he could hide it was to put all the stuff on the bottom of the case. The whole thing opens up, but he would put it at the bottom and put the hood on top in case the cops stopped him.

Before, it was mainly the older people and the people who drank wine. Then the drinking age got younger and they wanted beer, so he got that. That's when I really started drinking. If you go out and sell beer and people find out you have alcohol, then people come out of the woodwork, your relatives and stuff. At first they would buy, but when they run out of money, they would ask for credit. He used to give it to them, but they would never pay it back. When he'd try to get the money back, they would just get mad. Then the relatives won't talk to you anymore, won't come over to your house because they owe you money. So everything changed.

He got mad, quit, and started selling soda and candy. From that he learned that he could get other things, things that the O'odham ate a long time ago, that are no longer around because they don't plant anymore. So he goes and buys the stuff where he can find it, the stuff they used to eat. And he starts driving to the different villages, going west, south, east. From that, I started going with him. I just watched him, how he did it. I would drive the truck and go to the different villages, and he would tell me which way to start. Later, it came to where he would drive, and when we got to the village, I would stay in the back

and he'd drive up to the house and I'd hand out the stuff that everybody wanted. He would always carry potatoes and whatever he could get that the people eat, like the little squash, *shapijk.* He would go to the fields in Casa Grande or Coolidge and pick out the ones that he wanted, the little ones.

And they had *ga'iwesa*, that's corn that's roasted and then ground up real nice. Then you cook that and put a little lard in it. It tastes real good. Pretty soon he started selling the ground-up stuff, but it was in big chunks. But they wanted it real fine. So they'd usually come back and complain about the corn. When it got too much, he usually would tell whoever buys it that you have to grind it up some more. That went on until Mexicans started selling on this side [of the border]. So then he quit.

Watermelons and cantaloupes, honeydews. They have their own name for each one. The honeydew, they call it *miloni* . . . "old man cheeks with his nose," smooth and everything. And cantaloupes they call *o'oki ha tohtoni*, "old women's knees," because they are rough. They have different names for the watermelons. During watermelon season, he'd go fill up the truck, a big truck with a lot of watermelons, take it home, put them in boxes, and then start selling them, taking them around. Even when the season ends, and they'd all toast and rot, he would still take them, and the old people still bought them because they wanted something juicy. Sometimes you could barely taste the watermelon. I would tell him, "Why are you still selling this? I thought they were past the sweetness phase." But they would still ask for them. The taste didn't matter; it was the juice that they wanted. Because I guess a lot of them were toothless. [laughing]

During the winter season, starting in December or in November, they'd go to the orchards and get big boxes of oranges and dump them in the truck and fill it up and drive home. And they [my parents] used to have apricot trees. They would cover them so the birds wouldn't eat them. They would grab them when they were still green because they

FIGURE 41. Untitled

wouldn't leave them up there for the birds. So they would let them ripen in the box. He already had the boxes, the heavy-duty boxes, and filled those up and stacked them and then started selling them. Especially during the winter when there is no fruit growing around the reservation, a lot of the older people really like them because they want something with juice. They would say, "Fill it up for a dollar," or anything that is small enough to put in their bag.

He would go to Mexico, by The Gate [an informal crossing point at the border between the United States and Mexico near Sasabee, Arizona], buy cheese, cut it up, weigh it, and put prices on it. It would be

gone by the time we'd get back home. Everybody bought it. We used to make O'odham cheese too. They would come to the house to buy it, buy it for $5. About five inches in diameter, some of them were bigger. Those, I think, were $10 or $15. Every morning we'd go over and milk the cows and watch them make it, and by the evening it would kind of be like cottage cheese. We'd eat that with tortillas. [laughing] After that, they would put it in this ring, pack it in there, wrap it up, and put stuff on there to drain all the fluid out. Then they let it sit overnight, maybe part of the day. Then they took it out and people would show up to buy it before he started selling it on the road. He always liked that. It was good.

At one point he found out that he could make snow cones, and he got a crusher. He would crush the ice. He got the barrels that are insulated, that can keep things cool. He'd fill them with shaved ice and maybe have three or four barrels. He drove around and all the kids would come out and be dancing around. I saw this guy one time and he said, "Hey, you used to come to my village to sell stuff, snow cones." And his mother said, "Yeah, they used to run out there, jump around." They knew my dad's name was Salwa, and they would run out there and yell, "Salwa, Salwa, Salwa." I'd see them as we'd drive up, but I never heard what they were saying. She told me that later on.

He would buy other things, like sodas since they no longer bottled them. So he would go to Mexico and pick up all the cases of bottles. Then have the customers bring back the bottles and take them back and get the money. They liked that a lot. Right now I don't think anybody would do it now. If there was a dance, he'd go and get a lot of cases, and more candy and chips and things that the kids like. At night while the dance is going on, the customers would buy candy and cigarettes. And those big barrels [of shaved ice for snow cones], by the morning, most of them would have turned white, but they still came to get them, down to the last one when it's just water. I'd stay up there on the truck all night, until morning.

Then he started going to buy wholesale. He learned all that. When I began to understand, I realized the work it took him to change when he did something. Here in Tucson, he'd go to the wholesalers and buy stuff. He started selling bread and cakes and pies. He started with the day-olds, Holsum bread and Rainbow, and he would sell at his own price. Sometimes it's low and sometimes it's whatever he can. And

he'd check out the source and see how much they are selling it for. All that stuff.

So that worked out for us, until he couldn't do it anymore. Then I went out and started it for two or three years before I came to Tucson and started staying here, every chance I got. He would be still doing it, but not as much as he used to. I'd go help him, sometimes go by myself to pick up things. He knew everybody, some from when he was picking cotton. So every time he would go, he would stop and talk and talk, before he goes on. He knew a lot of those people. When I went, I would cover more because I didn't really know too many of the relatives. I know some of my relatives, but I didn't talk with them. Sometimes they would ask about him and it would take long. But I covered most of the west end. And the next time I went out, I would do the east end, and the south part in one day. And the next day I'd just go around the center and the villages.

These guys [owned the old store at Santa Rosa]. I think they're from Oklahoma, I guess. Their dad set it up. Back then they weren't paying anything, until later [the district] got them to pay $50 a year. [laughing] They don't have it anymore. They finally told them that the district was going to take over the store. So they quit and the district found out that there is like a sink hole underneath there. These guys have been pouring cement in there to try to keep it up. Finally after they left it, they told the district about the sink hole. [laughing] The district used the store for a while, until they said, "We got to get out of here." So now the only district store is the one at Quijotoa, way out there, about seventeen or eighteen miles [from Santa Rosa village].

My dad wanted to build a store. He picked the area near the Children's Shrine. There were some young guys, I guess, that were being drunk up there and they were trashing it. So he thought he'd wait for one of us to come home and start it out again, build the store, so we could take over. But it never happened.

I wanted to do that. I went back and I renewed the land claim that he [my dad] got. It would be good for a grocery store, but in the middle of the store I should make an art store. So I just never did anything. Now people are afraid because it is right there near the Children's Shrine. You can see where the water when it started to flood, that's where the water went. They all knew my dad and that it was already set by him. It was his already. I just changed it to my name. It's a really good spot.

People heading to Rocky Point [Mexico], they go through there. One time they closed the road somewhere, and there was a line of cars going through there, all day and all night, just a line of cars. When I was up there, by the rock there, I was sitting up there and watching all the cars, all the headlights at night. And I was thinking, "Man!"

FIGURE 42. *My Dad, Louis Chana*

They Really Raised Havoc

I used the maze on the basket because it is considered the life of the person or group (fig. 43). If you keep abusing it with alcohol or drugs, then the whole group gets torn up, you know, because it tears you up inside, it tears you up outside. It tears up everybody else around you, because of the drink. And then it is showing how you start dying from it. If you have children, then it starts going down to them. It affects them also, in how we are, how we treat our bodies, and the whole nation or the family at the same time. It's not just you getting affected and defected. It goes down the line to the children.

Then not so long ago I pulled it out, and then when I was looking at it I realized that things have changed and I wanted to add the gun, because now the gangs. Back then we had gangs, but they didn't use guns. They went out and fought. Every now and then somebody pulled a knife, but you'd never see a gun. I was going to add that in there, before I made any prints. The hat is for a little girl or a little boy. Either one. The gun, anybody can use that. I did it to show that once they do all this stuff, they die down here. You start unraveling; your life comes apart.

FIGURE 43. Untitled

The final thing is death, but the thing doesn't die there. It goes on to other generations. The person as they go down, it's good, up until it's too late. Then everything unravels and blood comes. When my aunt died, she was bleeding and stuff from her stomach. It was coming out of her mouth. I always remember that. And how she didn't want to die. She cried all the time because she knew she was going to die. So that's what made me think of the blood that came down. It's also affecting the children.

[My friend], I guess some of [his family] live in Mexico. His brother got busted out at the airport. The guy shot the undercover cop planted there to receive . . . I guess it was the money he was going to give. It was his cousin from Mexico who was the one that shot him. He was going to give him the money, and this guy was going to give him the drugs. And he went up there and shot him. He got in the car at the airport. It was a big thing there for a while. [My friend] wasn't the one who shot him. I think the one from Mexico is still in jail or out already. The rest of them that were together, they came out of prison.

That's what [my friend] did, he just got out of prison and happened to be in that halfway house where I was. He was telling me what had happened. I think he was in prison for two years or three years. Then they let him out and he was at that halfway house. He was still there when I left, and then a year or two later I saw him, after he got out of the halfway house. But he didn't . . . The way their life is, they drink so much, it killed him finally. I saw him that day, I guess that night when he was going to die. He came over and was getting gas at one of the Circle Ks on Mission Road [in Tucson]. I was going out to Sells [on the reservation] to sell art. There was something going on out there, a rodeo or something. It was early that morning, and I was there getting gas, and I didn't even notice him until he said something, "Where you going?" I turned around and it was him. I talked to him a little bit. I said, "Come on over." He just lived in those apartments [near Circle K], because I remember when I helped him move there. I was always there. Then the following week, I heard that he died in his sleep. They asked me to do a card over there at the funeral.

I remember somebody else talking about when they were younger, much younger, how they really raised havoc. One of their nephews broke into a [gift shop]. The way they built the shop nobody would see inside, but you can easily climb over the wall. That was the first thing I thought. So he and his friends . . . [laughing] Then when they showed

FIGURE 44. Untitled

up the following day after they did that, they were driving around, selling the jewelry real cheap: $5, $2, $3. [laughing] You know, it was kind of their lifestyle. They'd do that and then try to get rid of it right away. They put a small price on it. I didn't have any money then. . . . [laughing] But they caught them.

He was telling me one time they went to some pizza place over on Mission and Ajo [roads in Tucson], and some crazy guy left his car running while he went in the store. This guy, one of their nephews, was sitting out there, jumped out and got in the car and whoosh . . . took off. They were out for about two weeks, I think, before they left the car somewhere. But I guess they picked up their fingerprints and they got busted.

I knew another guy [but not Wild Bill] who told me a warning. "This is what happens. If I go into your house and I see something that I can sell or some money of a certain amount, no matter who it is, I'll come back and get it." He told me that. When I was graduating from Pima College, I had some invitations I was going to send out. He had a motorcycle and he wanted to go out there [to the reservation], so we drove out there on the motorcycle. I was sitting in the back, and it was chopped up so the seat was real narrow. And by the time we got back my butt was aching in that little area and he was leaking oil. Every time we would go, my shirt was black and I got it in my hair. So when we got over there at the first place we stopped that I left an invitation, he told me, "I'm not going to go in." It was my cousin's house and he asked me to go inside. I was trying to ask my friend to come in, and he said, "No, I'll just stay out here." And after we left, he was telling me, "Not that I'm rude or anything. I just . . . if I see something, I'll come back and get it some time. So I don't want to go into any of your relatives or any of your friends' houses, or even your house." Just like that. So he never went into any of the houses. I just dropped off the invitations and then came back. That's how it is. A kleptomaniac or something like that. That's what he told me.

One time he asked me to take his bike from Yuma and across the Colorado River to the reservation, the little town up there. There are a lot of fields in Winterhaven [California]. He said he wanted to take his

FIGURE 45. *Wild Bill*

bike over there and leave it. When we were there, we ran out of money, so he started taking things where we had been. We went to a bar and there was a family there. They were already there drinking and stuff. He said, "I know those guys." So we ended up going to their house because everybody was over there [at the bar]. We rummaged the house and took a lot of stuff, and he started selling it . . . $10. After a couple of days I got started feeling like somebody's watching us, following us around and stuff, and I told him, "I don't feel right. I've got to go home." He said, "Let's go over here and get some gas money." I said, "I've got enough gas in here." I didn't like the way it felt. It felt like they were ready to jump on us. So I said, "I've got to go, but if you want to stay, go ahead." But he says, "No, I'll go back with you." So I came back. He was in jail before for doing that. His brother was in there because he was ripping off a Marine at knifepoint, big old knife. So they picked him up and he was in prison. So he said he was doing that to go visit his brother because him and his brother were . . . [tight]. I don't know. It was crazy. I had to get out of there.

When we were here, he wanted to get away from here. Go somewhere, somewhere else. He started doing that. He would come over to the house and leave the stuff and then come back to pick it up when he found out who he could sell it to. Then I told him, "No, I can't have that either. You've got to leave it somewhere else." At that time, there was a car outside that didn't run, outside the house. Sometime I went out there and there was stuff. There was stereo stuff stashed in there, and I knew it was him. I was going to get it and put it away, but then I thought, "I should just hide it somewhere, so he won't take it." Then I went back and it was gone already. [laughing] Then I found out that it might have been my friend's stereo that he met a long time ago, the first time he came to Tucson. But he's quick. He doesn't mess around.

Some friends that I used to hang out with, they were a little band (fig. 46). This guy, they always called him "Mr. Calm," because he was always real calm and not in a hurry, never in a hurry. Just takes his time to do things. We used to go and watch him when they jammed. Then somebody, one of them, asked me if I would do a design for them. All I could see was their faces and what they do. So that's how it all came together. I don't think they're together now. They've always been around.

[There was another group], the guitar player for the group called Rez or something, formed by a Yakima Indian from northern California. The rest of them were Apache, and Navajo, and O'odham. Then Mr.

FIGURE 46. *Mr. Calm*

Calm started writing his own songs, and he was a part of it. He was the only white person in it. The others were Indian. They were so good. At one point they wanted to get a tape out, so they rented this recording studio and they went in there. They did the whole thing, one song each time, and it was perfect. The people there who were doing the recording said, "We've never had a band where they just played straight through and never made a mistake." They did the whole thing straight through. They broke up because the Yakima guy went to New Mexico to go to school, writing songs and doing other stuff and poetry. Then he met this girl and he told her about the band. Then they came back and she came with them. He put her in the band, doing tambourine or something, and the rest of the guys didn't like it, so that just broke it up.

They Really Raised Havoc **77**

So I Was Tired of Drinking Anyway

One time I got picked up here in town, driving around drunk, and I didn't know what I was doing. I woke up at the detox center and thinking, "I wonder what they are going to do with me? Are they going to let me go right away?" Usually, in twenty-four hours they let you go, but you can't just go. They have counselors who come and talk to you; the stuff that they will tell you, you know, so you won't drink again, or think about it. So they called me in that next day to see the counselor. I walked in. It was an O'odham. I was surprised, and then when he started he asked me questions, and then he started telling me what he was doing. I could picture myself in that part. I'm trying to look at him and wondering, "When has he ever been drunk?" I thought about it, the first O'odham man I met that had quit, quit drinking. He was telling me that he drank for years, hung out in, I think it was in L.A., that's where he was a drunk for years. He had been drinking for over twenty-five years, then his brother died. His brother died from alcohol, and that's when he made up his mind he was going to quit. He said it took a while, but now he said, "I've been sober for fifteen years." So that was a big influence on me, but I didn't think about it once I got out [of detox]. Every now and then when I was feeling low-down after drinking all night, I'd think about it. It took me a while to stop.

It was 1982. So I was tired of drinking anyway. I had just started my artwork and was getting into some of the things. I had just gotten the

stippling stuff down already. I had stuff in my trunk that I had done and I was selling those. I'd buy gas to drive around. Because I was mixed up, I would sell it to be sure I had gas in my car and alcohol in me. [laughing] I liked that, you know. So I was thinking that I wanted to keep on doing what I was doing, because I was just learning. It started to lift my spirits up because people saw how I was drawing, and they can relate to it. That surprised me even more. I wanted to quit, but at the same time I didn't want to, but I still wanted to keep on doing what I was learning.

I got picked up at San Xavier [Mission]. They were going to give me sixty days in jail, that's what the judge said. Then later they sent somebody around and called us in and asked us: "If you want to, you can leave the jailhouse, but you have to go to the halfway house and go through their program up until the sixty days. Then after the sixty days, you can do whatever you want to. If you leave early before your sixty days, we'll pick you up and you'll start your sixty days in jail." I was thinking, "I think I would like to do that instead of drinking it up." So I told them when they came back, "I think I'll go on to the halfway house." It's like a six- or eight-months total program, and if you really want to, you can stay the rest of the time. But if you stay the sixty days, you can leave if you don't want to go through the whole program.

So I decided I'd go over there. It depends on when the sixty days are over, how I feel. I can leave if I feel like it, but I already knew that I wasn't going to stop there, but stay the whole thing, just to see what happens. So I did that. I felt funny when I first got into the halfway house. Some of my friends are all drinkers and druggies. I got in in '82 and I got out in '83. People that knew me here in Tucson found out that I was there. So they would come and ask me to do some [artwork]. Actually the painting that Gary [Nabhan] used on his native plants book [*Enduring Seeds*, University of Arizona Press, 2002] [was] the picture that I painted in the halfway house. I did some other stuff for cards.

Then once during that time when I was in the halfway house in Sells, this lady had seen my work. She was working at the library. She put on a show and asked me if I could set up. She said: "I'm having some other people come. If you start, you can come and explain your artwork, put some stuff up." I never thought that she even knew. Already I was doing my artwork, but it surprised me when she asked me.

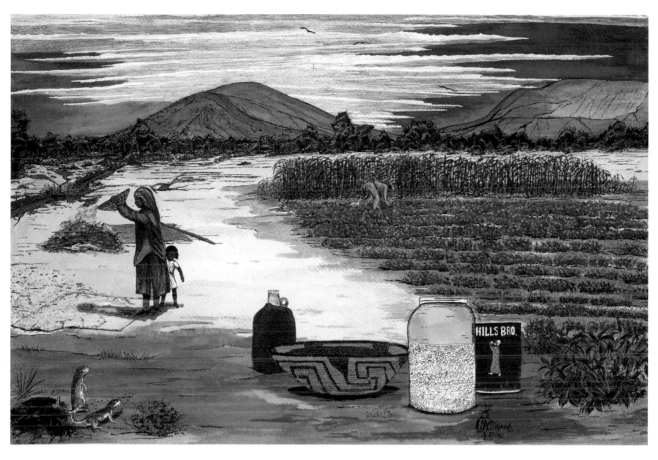

FIGURE 47. Untitled

I went through all the requirements they wanted us to go through in order to finish the program. I did that and I got my certificate for finishing the program. The people had already been asking about doing designs for alco-thons and things that go on with treatment programs. So I was working with pen and ink because that was cheaper for me. I couldn't afford paint. When I did paint, it was almost like watercolors because it's faster. The only thing that stopped me was the details. I wanted it to be detailed stuff so people can really see what it is. That's what makes them relate to the paintings, when I do all the little details. That really brings people down into my paintings so they can relate to things that I have [to say]. But I was wanting to paint; I wanted to paint. I always say that because I didn't learn from somebody else, so I don't paint as fast. When I do, I feel uncomfortable. When I paint, I stop and it takes me a while to finish a painting.

Now they don't have the halfway house in Sells anymore. Then once

I got out, I just kept on doing stuff and kind of expanding on my cards and stuff. Sometimes posters. When I think of something, I do it. Once I did one for alcohol [prevention programs] and I started getting business. People wanted me to do designs for a certain event that they have, but they didn't have any money. Every now and then I got paid, but most of the time I donated the design to them, just the design, but I keep the original. At first I was doing the whole thing. I'd give them the design if they wanted to keep using the design. But later on I was thinking, "I'm not making any money."

Of course I wanted to get rid of the drinking, but there were other problems that I needed to take care of. When I was doing this [artwork], I was thinking about that, you know. Even in the time I was doing this, I let go of a couple of [those problems]. I could feel myself, the change that was happening. I'd come across other things that I never experienced, but I know that I had never used the stuff, so eventually [the desire and curiosity] goes away by itself, thinking about myself, how I feel. But I'm just glad I wasn't drinking or using drugs then.

SUSAN LOBO: Here Leonard describes how he began selling his artwork.

So I kept doing stuff that really helped me, you know, to keep going, even changing from wanting to be a social worker which was what I went to school for. But at that time [before the halfway house], I didn't have a job, so I needed money, so that was just what came out, the cards. I used to go to the arts and crafts stores and look at the cards. There usually wasn't much in there, like animals or something. From that I picked that up to do my first cards.

It started with the cards, because it was easier and I didn't have to spend so much money. So it was almost Christmas. I wasn't working, just going to school. So, I thought, "Well, maybe if I make Christmas cards." And that's what started . . . trying to remember how it was Christmas out there [on the reservation]. The cold . . . we were inside the house and the smoke was coming out. It was cold and we had the fire in the stove, so that's what I started out with (fig. 48). Like gifts or something and other things like a cornucopia. So I was trying to do that with the baskets. Just certain things, gifts and nighttime and the coyotes come out and all the other stuff. And that's what I did. Made six of them. Then after, I went to Alpha-Graphics and put them on one page.

FIGURE 48. Untitled

And then when I did finally put them in a plastic bag, I didn't know how or where to go to sell them. So later on I started driving to my friends' houses. I did try to go during the day, but nobody would be home because they were all working. So that evenings I'd go around and ask them if they wanted to buy some. "Sure." And that's another addition to me to keep going when they looked at it and said, "Yeah, we'll take some." So still I ran out because there were five, so I made six. You know, they started buying them and that's what started me. So that gave me the initiative to go set up [a sales table] at [events at] San Xavier [Mission] for a short period of time.

I went to San Xavier [Mission] and had a little table and put them out there for maybe two or three hours. I did sell some, but from there I started thinking about what I can do by looking in the arts and crafts stores that sell cards. But that's where I started first by remembering the cards. That's not much of a picture, but they were selling, doing something with the O'odham designs and stuff. I've seen so much of the baskets, how we use tools, our houses, what I could draw back then. I was just starting to see what I could do. I don't want to work for anybody. I don't want to get up at 7 o'clock and be there at 8.

But I couldn't do anything else when Christmas was over. So I had to think: "Maybe I can just do them on the holidays, when the O'odham celebrate those holidays. Because they are the only ones who would understand my art." Even then, it was just the first time, but they bought it, so I figured, "Maybe Easter would be another good time to buy." So I started doing Easter cards, then it was later on I started doing other things besides the holidays. From that it started growing up. People started calling me and asking me to do posters and stuff for different events.

I put my logo on the back of the cards. That design was a little bug when I first started. Then it slowly changed here and there and it became like a Kokopelli. It looks like it, but it really is the bug that I started out with and slowly took its own shape and now it's the bug. The letters of my first name and my middle name is L.F. so I put that in the middle of the bug. Then I put my last name out in the side. The player, the flute player, I was just thinking that. When I was in high school I played in the band, played the saxophone. But I didn't want to put that in there, so I just put the flute player. And from there it just slowly came out to what it is right now.

But along the way, I had to learn how to make the cards, because

there is also a way to do it so everything goes together. The first time I did the cards, I did them the wrong sizes. I had to find a way for the people to send it, mail it or whatever. I saw these little stickers that had quails on them, so I put that in the package with it, so then that way, they don't have envelopes, just fold it over and put the sticker on it. I couldn't figure out how else to do it. Even some of those, the little ones, they weren't the right size. I found out that I needed to do them a certain size in order to get envelopes.

People shared with me what I needed to do. The first one was the cards that I made were all different sizes and I couldn't find the envelopes. When I did the Easter ones, I met this guy who was a printer. I got to know him and he told me, "You know you can look at the envelopes and see how big you want. If you want the small ones, they have envelopes and you can make your picture that size. That way you'll have envelopes." That's how I got into that size, the A2. That's the envelope.

The first printer, I couldn't get him to use the better paper than what he used for fliers. He'd print out so many and I'd have to go fix them up. Before he wouldn't cut them, but after I said, "Could you cut them for me, please?" he would cut them to the right size. I folded them myself. I still do, because they charge you so much to get them folded.

I try not to look at it that way . . . that you can't make any money making art. What really helped is the cards, selling the cards to make enough to cover. But there is the copy machine out there. It's five dollars to do all this stuff, plus all the people who work at where I do my framing. They help me along by letting me pay them later when they do stuff for me. Also the printer, he lets me do stuff and then pay him later. When I have a big sale, then I pay him, and get more done. Some of the stuff I have it printed, because that's what people ask, "Is it printed? Is it on a printing press?" Yeah. So I tried to do it with Xerox but it's not good.

A lot of the stuff I did at the beginning, I used to just give it away. If I sold it, it probably was a dollar or five dollars.

SUSAN LOBO: Here Leonard describes how he developed his stippling and other techniques.

What I've gone through is self-taught, so I've had to do a lot of thinking and a lot of practice to actually make a picture. But when I first started, I was at Pima College. Looking through the magazines in the library, I saw the little dots and stuff that computers make when they make pictures and it kind of made the picture look real. I always wished I could draw like that. I started out using a pen and the lines, and I slowly turned it into dots as I went along, slowly changed it.

FIGURE 49. Set of basket and animal cards. (*a*) Hohokmal (butterfly); (*b*) Rattlesnake; (*c*) Ba'ag (eagle); (*d*) Huawi (mule deer); (*e*) Chuk Ud (owl); (*f*) Nakshel (scorpion); (*g*) Kumkch'd (tortoise); (*h*) Ban Gohki (coyote tracks).

The only reason I did pen and ink was because it was cheaper. The pencil was more expensive than the paper. Then a drafting pen. Somebody told me I could use that because I wanted to do the dots. I didn't want to do the lines. It was too strict — it kept you in the lines and didn't let you move around. So when I started using the dots, that helped me to feel like it's actually moving and not restricting you in between the lines. Some parts I sketch out and I start adding, just looking at it, start stippling or doing an outline. And then other times I just look at it and then it pulls around where I want it. The thing that I'd like to write about on the picture doesn't come to me until after it's finished or during the time that I'm working on it. Then it comes to me.

After that I kind of started teaching myself to paint. I can see [in my mind] the fields, but I had to learn how to make it smaller, so I had to think of a certain part of it, not the whole thing. Or if I do the whole thing [a landscape], I have to make [some things in the background] smaller in the picture. I figured that I'd lose the background, because everything else in the front was larger. Just going slow and learning as I go. If I feel uncomfortable with it, I quit, look at it, then start doing it depending on when the urge comes. I feel what I need to do to make it the way I see it [in my mind], even though it doesn't always come out that way. It sometimes still does that thing that I'm uncomfortable with: the distance or the bodies or whatever.

I was thinking about that one time, the way that they [other artists] do it. I couldn't stay in that space. I wanted to bring them into the picture, so I would go right off the edge of the picture. The depth, I'd try to make it so you could see back into the background, so it makes you feel you are going into the picture. I look at some of the paintings at the center and that's where your eyes go; but on the edges, it's kind of, it's not real, you can't see it. I wanted to spread it out to where you just go off the edge. So that's my feelings.

SUSAN LOBO: Here Leonard discusses the other artists who influenced the development and selling of his art.

The first artist that influenced me was Gus Antone. The first time I saw his stuff, he was working for [Tohono O'odham tribal councilman] Cipriano Manuel who was trying to revitalize the language. He had Gus do faces with how to pronounce the words. But it was more like cartoons the way they made the lips and the tongue for O'odham words. I liked what he did, but then all I saw of what he did was the cartoons. I said, "I wish I could draw like that, the cartoon characters, but not really thinking about it." He could just sit there and do it real fast. In a minute, he would have the face, the cartoon characters. I always

FIGURE 50. Untitled

wished that I could draw like that. Then I saw Gus's other work, how he did things. That inspired me more, because he would do the ramada different ways. Before I just had one look which is sideways. What he did was to put it in a different way where it showed how it looked, like how it had the posts, at the different angle so you can see the whole ramada.

After I saw his work, the first print that I did was the woman under the ramada combing her hair (fig. 50). But what I really wanted to get was the ramada angles. I was trying to get that look, instead of just that straight look, but from a different angle, getting all the things, like the roof, and the different ways of putting the poles, and putting the olla in there, all the different things that we have. You cook out there and the water's out there and the tools you pick or harvest your food with. The things that are wet, we hang them up so they'll dry. That's what I was thinking of when I did that one. That's what I was more looking at, if I can get it to look the way I see it. The only thing that didn't come out right was the clouds, because I couldn't really see the distance, how high the clouds should be.

An Apache from San Carlos, Duke Sine, was my friend. He had been doing art for a long time. He was going to make some prints. One of his friends used to work at a printing place, so he gave us a break with the price. He put two of my pieces in there, the one of the woman in the

ramada that I was trying to put at the right angles, and another one of three kids. Those were my first prints that came out.

I didn't know he did art. The only way I knew it was that he was in a van that said "Art." They were at a place and they were jamming. That's when I found out that Duke Sine was an artist. He told me what I can use. I used to use typing paper. I'd draw on it. He didn't tell me about that, but showed me how you can go to the store to try to sell your work. "Just tell them how much you want for it." So I would do that on typing paper. I went to this one store [in Tucson] in Barrio Libre, next to the community [building]. The guy there, he looked at it and he really liked it. He said, "I can tell that you are doing it on your own." Just the way I did it. He said, "It's real good and I like it, but next time when you do it, drawings or whatever, paintings, try to get the right paper, the heavy-duty watercolor paper. If you use that, the color will last longer and it won't fade on you. Next time when you do it, bring it over. I'll buy it." Then I started using that paper, but I never went back to that place. I usually don't go back to the same place, unless they buy some.

I started going to my friend Keith [Kleber] over here at Silverbell Trading [in Tucson]. We met at the University of Arizona's Christmas Arts and Crafts Show. They have it in a small area in front of the main building. That's where they set up. It was probably my third or fourth setup in a show, because I had just started. I had gotten in with my friend, Al Peyron. At that time I just had the cards. I didn't have anything else. Barbara Rose and Keith Kleber saw me there, and she bought some of my paintings. About a month later she called me and said: "I think I'm going to open up a place. I'd like to buy some of your cards to sell in there." So she started to buy stuff.

When I first started, I guess I learned from my dad that you have to sell it wholesale for half of what they are selling it for. Like $2.50 and then they would raise it to like $5. That's where I started selling, at Silverbell [Trading] in '86 or '87. From the store we used to go over to Li'l Abner's Steakhouse, eat there. Now they are buying my paintings and they are going better there than anyplace else. Then they tried out my T-shirts. That went O.K., but went faster at some other places. Then the paintings. They went fast. They'd call me back and say, "Whenever you have some more, bring it over." So those little paintings, they sell real quick. I did a lot of that because that's what they wanted: gathering saguaro fruit and making baskets.

Now I already have orders for some other paintings. It's always a

pressure all the time. I did it just for myself, but once they start ordering, I'm doing it for them and not really for myself. It becomes a pressure . . . hurry up. Sometimes I don't get to them, or something else comes up, something that's probably more important.

I know all of them [the O'odham artists]. Just the way they do painting. The way they did it made me want to try it out and see if I can do it. If I can, of course, it's different from theirs, what I come up with. It wasn't until later that I found out about Mike Chiago. He's been at it for a long time. So he's kept me going, doing stuff. Mike was going to school for drafting. Those two, Mike and Gus, that I saw do pretty good. I think Gus does more stuff on whatever he thinks about. Like the last time I saw him, he had a bunch of goblets that he was etching the maze on. Like a wine glass. He did some cards like weddings and baptisms. He does a lot of different things, trying it out. And Mike has many pictures. He would do it real fast. He learned how to do it I guess from the drafting school. He kind of uses the board to paint on. I never thought about using that. It's pretty fast.

Van Gogh is the one that tries to capture the wind blowing through the grass. The guy who cut his ear off. He tries to capture the wind going through the grass, the weeds, and the trees. He makes it wavy looking. I like that. At first I didn't because of the way he did it, until I read about it and then I saw a documentary on him, and that's what he was doing. I liked that after I could see it, but before, I was trying to figure out what he was doing. The other one is Michelangelo who did the human forms just right. That's what I'm always trying to catch when I do people. I try to do it like how he did it. I did a lot of study on the body, the hands, legs, and how they move. But I always like his pictures, his statues, his sculpting. Those are nice.

I hear from people who look at [my work] and say, "Oh, my art teacher may not like this, but it looks good." That's what they were saying when I first started. Even if there is just one person, whatever they see, you know, if they feel good about what's in there, what happens to them, that's good enough for me. Every year I did new designs for cards, and they always came back looking for new stuff, saying they always frame them. I think about it and sometimes I do new designs, until something else pulls me away from doing cards to work on something else.

When I'd give a presentation, I'd tell them what I did, how it started, and how I'd draw tepees and feathers and bows and arrows, and Indi-

SUSAN LOBO: Leonard talks here of how he moved from depicting generic Indians to a focus on the Tohono O'odham culture and people.

ans with war bonnets and painted horses, but I never felt a part of it, I never felt right drawing Indians. It was more like Hollywood Indians, because I didn't call myself Indian. I was O'odham, Tohono O'odham. Then I wasn't connecting myself with this. The ones that I drew and the ones that I saw in the movies or in comic books, you know, those are the Indians. We're O'odham and we're not them. I found out that I could do things from my culture and my traditions that I felt more at ease with. I've been around it all my life, so it didn't feel like it was anything that anyone would be interested in: the *watto*, the pottery, baskets, and all the stoneware we used to use for utensils, for cooking utensils. But when I started doing it, I noticed that people from here, you know, my own tribe, they really got into the pictures. They could relate to them, which even made it easier to work more on different things. That's what gave me the inspiration. When I first started doing it, the only thing I could focus on was to make them see the O'odham house and ramada. I got a lot of feedback, good comments—how they remembered it; how it brought back their childhood. So I have to make it better. Every time I did it with more details. That made it even better, so they could see it, see themselves.

I guess that's what made me change from the Hollywood Indian to my tribe, the Tohono O'odham. I felt more connected to them than to the warriors, the Plains Indians or even the Apaches. I didn't want to draw them once I learned where everything fit. Then I felt comfortable about that, and ever since then, it's just been things at Home [that I draw].

Just like when we used to set up at San Xavier Mission, and we'd see all kinds of people from all over the world. They'd come by, and one time these Japanese people came by and they looked at our stuff, and they were standing there looking around and one of them says: "So where do you have the village? Do they still dress like that? Do they still sleep in a tepee? Where do you have the tepees or do you go through the wall there?" There is a wall you can walk through and go in the back of the church. "Are they back there somewhere?" The village is all around us. No tepees. We never had tepees. We had huts and stuff like that. . . . Yeah, we'd come across people that would say those things. Yeah, that's what they do. They'd come over to the store, the plaza [across from San Xavier Mission]. They're looking around and pretty soon, they walk back out, stand out there and they're looking for the village. [laughing]

Sometimes people come up and say, "I still like the picture you did for me." And I say, "Which one was that? [laughing] And who are you?" This guy came over and was saying, "Yeah, I still have those pictures and really like them. I have them on the wall. When are you going to make some more; when are you going to do color?" He kind of looked at me like, "You should know who I am." [laughing] But you know, I don't mind.

The Courage to Change
My Life Is Open

Our alco-thon is mainly for Native Americans, but it's also open to other people that come in to support themselves from going back down. They are always looking for ways to keep themselves sober. Like I say, it's for the O'odham people and other Indian tribes that have their AA groups, halfway houses, or whatever's involved with alcohol and drugs. They come from Apache, Navajo, Mohave, Wala pai, up around the Grand Canyon, all over Arizona. They'll come and each group will do a presentation of what they're doing. Some of the people will talk about their life and how it was, how much it's changed, why they're quitting, and how they keep themselves afloat. They go all night. Each group that comes in will do their presentation . . . sharing what they're going through in their life; what they're looking forward to. They always tell us, "If you can stay up all night when you are drinking, can party all night, you can do this sober." The O'odham and the Pima, that's what they say, because the dances last all night. So if you can stay up then, you can stay up tonight. [laughing]

When they break, all the food is donated, and they put it out on a long table, and you can go and help yourself. Different groups, if they cook something, they'll put it out, you know: tortillas, bread, store-bought bread. They always have different things.

In San Xavier they had it in the community center and others will have it in other spaces. I've never gone to any here in town, in Tucson, but mainly like out on the rez they're usually in a gymnasium that's

big enough to hold a larger crowd. Over in Phoenix they had it in the Indian Center, in their auditorium.

Sometimes it can be men and women separate, but most of them are put all together. It's up to anybody if you want to come and learn, even if your addiction is way different . . . the main thing is drugs and alcohol. It's all things. They want you to come and learn, you know, learn how to get away from whatever you're into.

They have Al-Anon for those guys that aren't alcoholics but are with somebody or know somebody they want to help out, but they are enabling them more than helping them. You have to learn about them and understand what they were talking about. It took me a while to learn what it all meant. I always think, "It's O.K.," but what they were doing was enabling. I kept going back and I hadn't even gone up [to talk] yet. They teach you how to handle that.

This is for the alco-thon (fig. 51). That's why I put San Xavier [Mission] in there, because that's where they had it. One time I heard my brother was saying, when he was drunk: "The O'odham life is all along the road," he said, "and if you really look, you'll see all the bottles and the cans alongside the road, plus you see the crosses. That's what's killing our people. And it's not going to stop. It's going to keep going like that." And I was thinking, "I think you can stop." Then when I went to the halfway house, I learned that you can stop.

This [art] is '91 (fig. 52). A lot of my thoughts went into it, because, you know, that's the way I saw myself when I first started quitting, three or four things that I was addicted to. When you have problems and addiction that's the way I see it. Some people, a lot of people, will try to quit their addiction, and they climb up with the help of what they call "a Higher Power." Here I used the eagle as the Higher Power. That one has the maze of life on it.

[Here in the picture] they are like little round balls, and whatever you do, it's all happening in there, your life. Once they start learning about themselves, why they are doing things that are hurting them or killing them, then they quit and they start moving back up to where they can control their life. You can be up here on your own, instead of having them help you. Some of them don't even get up here; they just fall down. You can see a lot of them, because they have nothing to hold them up. When you try to think of what you were taught, all that comes back is that you are not supposed to do these things, but there's

FIGURE 51. *There Is a Solution*

FIGURE 52. *In the Fight for Life and Death*

no support to hold you up before you can be solo. It all depends on how you continue your life, to bring you back up. You let go so you can continue on with your life.

A lot of people don't know what else to do once they're alone and nobody's giving them a hand to hold them up. When they are up here, a lot of them get depressed and go back to drinking or whatever their addiction is, and they start going slowly down. If they give up too fast, then they start sliding back down. And then slowly the next thing you know, it's picking up speed, and they don't know how to stop it. By the time they realize it, it goes faster, and this is where they land. So I have crosses down there, because a lot of people don't make it. That is death for you, or you can go back and start again. That's the good thing about addiction, the only good thing about addiction, you can start over again and come back and let go. A lot of people that are off of their addiction are doing O.K., but they do this many times, just to finally really realize that that's not what you need. Then they end up . . . in life what you want to do or whatever God made you to be in life.

The picture is so they can see it and understand it and always have it with them, to remind them of what is going on. I was trying to get them to see that, instead of trying to learn it and follow it in language in whatever way they learned it. That was the hard part. When I first started, I'm doing these drawings, and how can I make them understand what I'm trying to do? That's when I started writing all the sayings that will direct you to that point. But even after that, there is a lot more to share about the picture that's kind of hard to understand. Some of the pictures [of other artists], I like them and I would like to find out what it is about, but all they would have is the title and some words, and it didn't really tell. It kind of frustrates me, you know. I want to find out more what the picture is about, where it came from. [laughing] Yeah, even writing on the back, it's just a quick thing, since you can't see all the stuff. I didn't want to write too much to bore everybody, so I just skimmed over it. Plus my English writing isn't too . . . I use the words or whatever I need to.

It says, "In the fight for life and death, whenever your life hits bottom, a faith in God casts out fears and lifts you out of death and back to life."

[The snake] is addiction, whatever the addiction is, it kills. If you are willing to save your life, then somebody will come and rescue you, bring you back up. That's the storm in your life, going through that.

But once you get above all that, you can see why your life is like that and where to start working on it so you're free of your addiction. They said sometimes that you don't see that much around your life, that it's depressing and you don't give it enough chance to work. Either you die, or you pick yourself back up and somebody will help you; somebody is there in the right place.

I look at the moon as the last warning. The moon is always a warning: it's late, time to do something. If you don't do anything about it, then pretty soon it will overtake you in the darkness, and when the moon shows up, it's the last chance. Once it goes away, it's darkness and you've lost. The sun always brings the day and the brightness, and the outlook on your life.

This eagle is looking after you. They say it's a Higher Power and that's all they do—they help. Help you if you need help and you want it. They're there to help you. Once you find out that you can survive, you can be out there by yourself taking care of yourself, out in the world and not be one with tunnel vision. You see everything around you. Because there's other things you can do without having to drink or eat a lot or whatever.

Usually I see that it is the male eagles that are the ones that are doing it, helping other people. I've seen females, but they are working mainly with the female's group. It depends on your skills and the effect on the people you have. I must have the male in mind, because that's what I went through.

Other people's lives, some of them don't go through all this, they just know what they want and this keeps them up, keeps them going. But most people don't have that kind of background. A lot of things are suggested to them, but they don't know how to look for help, or the addiction is much stronger. But once you get up there and you go back down, you realize that it's a different feeling. A lot of people don't give it a chance to work what they learned, to work with it and stay out of the troubles they get into.

This is one of the pictures for my time when I was coming out of drinking, and drugging, and stuff (fig. 53). I guess in my explanation of how I felt going through that I couldn't write down in words. The only way I could do it was picture-wise. This was called "Courage to Change" which was one of the nine steps that you go through when you are in the half-

FIGURE 53. *Courage to Change*

way house, changing your life. The round maze, when I started, it was more three-dimensional because of things I did for myself. When I found out about myself, that's the maze finding out who you are, why you did things the way you did, and why you drank. I always hid it from myself, denial I guess. Things that people won't know about me, so I hide them.

So once I went through the AA meetings and did things, it opened up myself to me, who I am, so the three-dimensional [maze] was done away with, and it became a flat surface because there is nothing to hide. I look at it and see where I'm at. I'm open to anybody who looks in there, especially myself, if I intend to hide my feelings or hide who I really am. So the flat part of it shows that I am open, my life is open. When I do that, I can see around myself that there is another world, other areas, and there are things up there that I need to find out about.

It takes courage to come away from your safe place and take the leap of faith. Once you do that, you automatically find out you can survive out there, that it's in you, the survival. All you have to do is take that leap and as you go down, you learn all the things you can do to survive when it comes to where you become the eagle. You are out there taking care of yourself.

That's Baboquivari [Mountain] down there and the Black Mountains there. This drawing could be anything that you're hooked on. It doesn't have to just be the drinking or the drugging, anything like maybe your eating habits. All you have to do is take the leap and find out more about where you can survive on your own without having to stick to your own little corner of the world there on the ball. It's just taking that leap off of the safe place you're at. It may look like it's scary, but it's not really because you have a built-in protection, to protect yourself once you take that leap. Once you find out that there is a world out there that has plenty of things that you can do to survive, to make your getaway from this addiction, then you just have to take that courage to change, the leap of faith. It can be anything: faith in God or from your religion; to change your life, to make it better for yourself, and not just do the same routine over and over; get your mind out of the gutter if you are drinking and drugging. This was just what I went through and wanted to share it. I didn't know how to do it until one time I had this vision, but I didn't know how to put it together for a long time. It was in my head, but I couldn't see it. So one time I just started working on it and all this stuff came out.

This is another one that I've done (fig. 54). Joe Henry was the one who was working, setting up the alco-thon for four or five years. He's O'odham. He first got me to do that. I met him in the bar one time, and I showed him some of my earlier stuff. He remembered me from then. So when he quit drinking, I had already quit drinking. He called me and told me what he had done and was working on the alco-thon, and he would like for me to do the design for their poster.

FIGURE 54. *Carrying the Message*

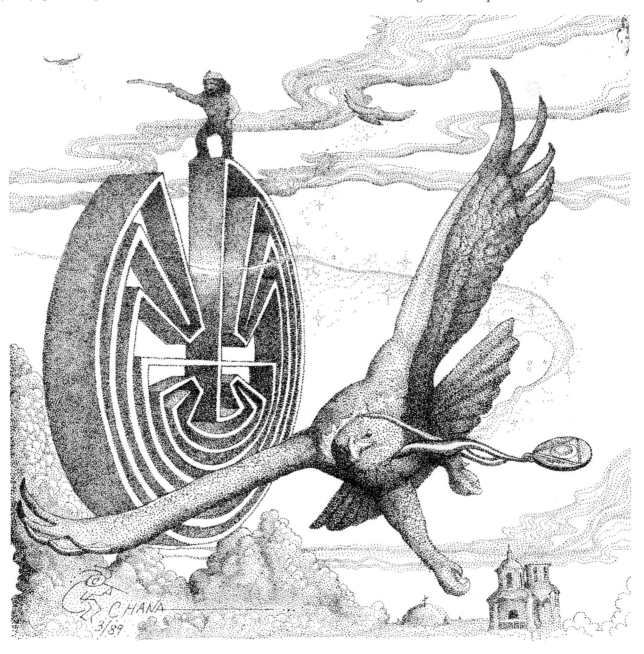

The Maze Broken in Half

This is my first, the first picture I did for the American Indian Treaty Council (fig. 55). I was kind of unsure of what I was doing. It was the first meeting they had. There is their logo in there. They were meeting with South Americans, so I made the Indian on the right looking like South American, and the other one on the other side like tribes around here. There is Baboquivari [Mountain] in the back and the basket design. I had the Treaty Council design on the ground (and in the smoke) there. The pipe in the middle. And the cactus with the owl because they were going to that village. They call it *Chukud Kuk*, The Owl Hooting. That's where they were to do this one [meeting]. When the Navajos showed up, they really didn't like the owl [in the poster]. There was a big thing about that. I just took the owl out. On some of the posters and stuff, I had to take the owl out. So this is the older piece. [Leonard is referring to the Navajo belief that owls are associated with something negative.]

This one was my first one [about the border] (fig. 56). You can see my bug. That was how I started, my logo, my cockroach. There was the first meeting when they met with the O'odham in Mexico. They are more like the Mexicans, a little bit quicker, in their words. Some of them are old O'odham words, and others are words combined with Spanish. You have to really listen to them when they are talking O'odham. They are real fast when they speak Tohono O'odham.

They met over at Pozo Verde, an O'odham village. They've been

SUSAN LOBO: For the meeting, Leonard traveled south across the U.S.-Mexico border with the American Indian Treaty Council group.

FIGURE 55. Untitled

there and they never let it go because that's where there is a natural spring. It's apparently a big area. It's a historic place, that Pozo Verde, to O'odham. I guess during the rainy season there's more water coming up [from the spring]. During the summer it's kind of slow, but there still is a lot of water.

The Mexican ranchers were trying to get it, the water, but they could never take it away from the O'odham. But the ranchers made their area smaller. They knocked out the O'odham fences and moved the fences to try to get the O'odham out. The O'odham would go back and would knock down and move [the ranchers' fences] back to where they were originally. They kept doing that until the Mexican ranchers started putting them in jail, taking them to one of the towns near Caborca [Mexico]. That's where they would put them in jail. The ranchers would be abusing them while they would be taking them over there. They did that to all of the O'odham ranchers. They moved the boundary lines all the way, almost to the houses. That's what they did. They tore down the fences and moved them to just around that one house. The O'odham had cattle and a lot of them either were killed or taken.

When this was going on, we were going through the area, looking at what they had done. We got to this one place and just maybe four or five cows [were there], and they were all really skinny. The area where the Mexican ranchers had shrunk it down to, there was no grass, just the house where the people lived. But outside the fence there was tall grass and fat cows walking around. I don't know how big the O'odham land was, but that's what they moved it down to. Like it's a fence around the house. But actually, that was the village.

We went to Caborca. They have an Indian Center there and they get money from the government, but whoever was running it at the time or whoever gets the money, they used it for themselves, you know. One time the government sent them equipment for wells, to make wells, and the town just took all of it. The ranchers used it on their own land. Then they would tear down the O'odham fences when the O'odham were migrating, moving from one place to another, but always coming

back to the same place. Once they moved to another place, the ranchers would come and take their land while they're not there. They would say, "Well, they're not there. They don't use it." The government, they don't do their follow-ups and stuff so they don't know what's going on. The O'odham would try to go back, and they wouldn't find anything because the Mexican cowboys would chase them away, and tell them, "We don't want you to come back anymore." Then they would kill them if they wouldn't go away. Then they would just kill them, so not to worry about them anymore. So the [American Indian] Treaty Council came.

That's what this [art piece] is about: the split since they put up the border (fig. 56). The [International Indian] Treaty Council came in and that enabled us to meet. What they did, they contacted the people on the other side [of the border] and set up a meeting to talk about what they need to do to meet with the officials from Caborca where the money is actually sent. So this drawing is where they are pushing it together. It means coming together.

I just did that ["96" in the drawing] on the marker. On the marker it usually has a number on it. "96," it also meant something else. You know I was upset with all the things that were going on. That was the time I actually learned about all this and I related to that. When I heard, you know, stories that were told and which I thought were just stories,

SUSAN LOBO: Here Leonard talks about the ongoing process of attempts to resolve issues as a result of the U.S.-Mexico border that cuts across the O'odham homelands. The International Indian Treaty Council, with their main office in San Francisco, heard of these problems and organized a conference to bring these issues to the forefront.

were actually true. It was upsetting. I did stuff like that, the "96"; I did little things for myself. [laughing]

Same here [at an earlier time, on the United States side of the border], you know, at Tubac and Tumacácori, and up there at Arivaca. Up to the San Pedro River, because the Apaches were right up there, right next door to the O'odham. They [the Tohono O'odham living there] were the ones to get raided all the time by the Apaches. The Elders used to talk about it, like at night, tell us stories. Yeah, you know, then all the O'odham were called Pima. Then when the border came up and the ones that moved from there to the desert [north of the border], then they started putting the name Tohono O'odham. Maybe some of the O'odham lived down that way [near Tombstone, Arizona] because the way you see the old pictures of O'odham selling pottery there. There might have been some living there at the time and got forced off the land, because at that time the [American] reservation was being put up or marked off. So I think they did that. Yeah, you know, then everybody was called Pima. That's what they were called before they separated. The whole thing. Then when the border came up and the ones that moved from there to the desert, then they start putting like Tohono O'odham.

When I saw the houses there [at Pozo Verde], there was only three families that lived there at the time. The Treaty Council group had gone to tour down farther west along the border, and some of us had to stay in Pozo Verde, stay with the Elders. It was my Elders. The lady, one of those cooking, I asked her where the witch lady Ho'ok lived and she said, "In those mountains. You have to walk around and look for it." The stories I heard about the witch, she would go and take the kids from their home and she would eat the kids. I used to hear that that wasn't true, but when I went to Pozo Verde, they showed us where the witch lived, where she died, and where they did the dance that put her to sleep and carried her up to her cave and covered it up, burned it.

So we went and walked around and went the wrong way. Then somebody came later and said it's on the other side, somewhere. So we all climbed the mountain and went on the other side and were looking around. She told us that lightning had hit the top of the cave and it caved in, but you can still see where they burned the witch. So we found it and tried to go in there, but it was too far back. But you could see the black, the rock where it was burned. Inside the cave there is this big old heap like the foot mark. Some of it, just the tip, and some of it

the whole foot. They were saying that when the witch started to burn, she woke up and was trying to get out, but couldn't figure [out how]. The footprints came from that. She could make herself a huge size. She jumped up and hit her head on the ceiling and cracked it. I'itoi went over there and closed it up and put his foot on top. They said it used to be there, but once the lightning hit it, the footprint fell apart. We were up there and we took some pictures and went back down.

Around where the village is, maybe a half to a quarter of a mile, that's where the O'odham used to live. You could see where they used the ocotillo plants as a fence. It started growing like that in little squares. Then a little farther down there was a big clearing and that's where they did their ceremony, and they still put their blessings in there. That's where they invited the witch to come and dance and smoke and drink with them. And whatever she smoked, that put her to sleep. Knocked her out. They had already chopped the wood and stuff and stuffed it in her cave while she was away. When she fell asleep, they carried her up and put her in there and lighted it up and covered it up with rock.

Then they took us to where the spring is and there is a road that goes up to this big mountain. There is a big rock there with all these holes where they used to chop stuff, and they said that's where Ho'ok would go and chop up our kids, kids that she picked up. That's what the Elders used to scare us with. "You better behave yourselves or else the witch is going to come and take you away. Or we'll call the witch and she'll come and take you away, eat you."

I think there's probably one or two families living there [at Pozo Verde] now. You can go over there. It's not too far south of the border. There's a road that goes by there and goes to the top of the mountain. It must be about ten miles from The Gate [an informal crossing point at the border between the United States and Mexico near Sasabee, Arizona] that's right on the border. A lot of those people moved to the United States when the Mexican ranchers were telling them: "You guys better go. They'll take care of you over there. You know, the government will make you a house. They'll pay you." That's what they were telling them, so a lot of them moved north over [the border], but you know, they didn't have nothing, no jobs, just villages.

[I did the poster for the] run the International [Indian] Treaty Council was doing (fig. 57). When he [Floyd Westerman] was coming, one of the members came and asked if I could do a portrait. So I said, "Yes, I'll give it a try." That's when they began the talks between the

FIGURE 57. Untitled

O'odham in Mexico and the O'odham on this side. They involved the Mexican government and the districts right along the reservation border. Actually, that was some of my first artwork, for the [Treaty Council] meetings. I did four different ones. This is the one they used; they sent it to Floyd.

It was getting close to when the Treaty Council was going to come. They always do that. They would give me two weeks to do stuff, to do the design and the wording. They first ask me to do a design. They gave me different pictures of Floyd and I looked at those. I was using lines and dots. Lines on his hair, and then I added in the dots later. I used a lot of the lines on the edge, before I filled in the detail. I was just trying to get it done. Later on, three or four years later, on some other designs I started using dots instead of lines. At that time as I said, they only gave me a certain amount of time before they show up, and I had to hurry up, so a lot of it is lines.

The lizards happen to come across the runners' paths. They are jumping over it as it comes out. The desert has lots of lizards. We used to do that, run from school to home when there's a lot of lizards and those little groundhogs or squirrels or whatever they call them. I go back to when I was a kid. Sometimes I'd run across a lizard. It also shows Baboquivari in the background.

When the O'odham had a [competitive] run a long time ago, some of them will cover themselves up all up just with white and some just put the stripes. It was when they have a run people put up a lot of stuff to bet against other groups. They came from other villages. If you are running and painted a certain way, they know you are a runner. Then, I guess, this way, you won't cheat. You won't just be standing somewhere and start running at the end. That's what they were doing before. That's why they quit. Because they weren't doing it right. And then they would have their medicine men stand somewhere and hex the other runners. They would do different things. And finally they just said, "Things aren't working out, so we'll just quit doing it." They would go to any extent, I guess, except killing them. Yep.

I did one for the Treaty Council. They were meeting at Baboquivari.

They found this guy, some realtor, his wife was really into the Treaty Council, anything Indian, so they got him to print these and I think three or four other posters, because they had the money. It's pretty expensive to do that gold trim. Treaty Council went up there and showed them and he really liked it. So they went to the print shop and

ordered it right away, and it came pretty fast. I had a lot of prints of
that. A lot of people liked it, and they still had some left. At that time,
Robert Cruz moved out to the reservation so he took all the prints. So
what he gave me, a bunch, I gave them all out and wanted some more.
I asked him when he came back. He said that the rain got in there and
destroyed them all . . . all those big long prints, that and some other
designs. And they all got destroyed, but people still asked for more.

They used to say that when the mine was going on in Ajo [a town
just west of the reservation] where the O'odham and the Mexicans live
they would dynamite some area nearby and those rocks would come
through their roof. Now the mine is closed out. You can go back there
and there is a little church that the O'odham used. They turned it into
a museum and have a lot of stuff in there. All those houses that the big
shots stayed in [are still there], nice big houses and then the mansion
where the main guy stayed.

[In this picture] my friend got killed by the deputy sheriff (fig. 58).
For a short time we were good friends until he got shot. They had been
fighting outside of the bar in the parking lot. At the Ajo Bar. He had

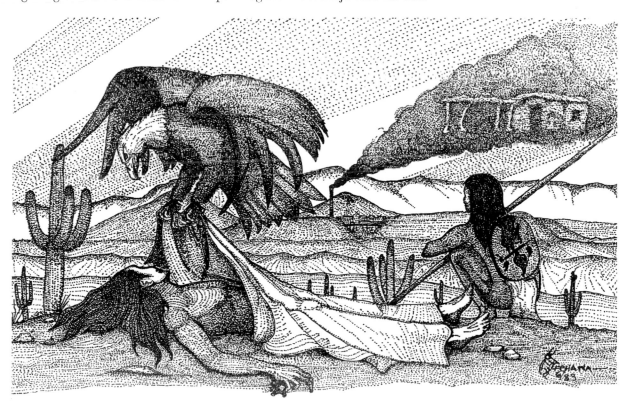

FIGURE 58. Untitled

long hair. The sheriff's star, the detective's star, is in his hand. And the eagle is taking his soul from his body. His name was Philip. The Treaty Council went in there and they protested. This is one of the ones I did for that. They always watched whatever the police did. I put the guard in there and the Treaty Council logo in there. But [the law enforcement] did it again not too long ago, just a few years ago where this cop shot the guy while the family was watching, killed him.

This was maybe two years later from the first meeting they [the International Indian Treaty Council] had on the border (fig. 59). Only the first one (fig. 56), the rock was open and they are pushing it together. The second meeting is when they got it together, and now the O'odham in Mexico and the United States are coming together. They were trying to put something together to stop harassment along the [U.S.–Mexican] border, inviting all the groups from all the Native [communities] along the border having the same problem trying to cross back and forth. The first meeting was letting people know that something is happening on the border and they need to understand that. The second one was to bring the rest of the people that are along the border to share their problems and see if there's a solution they can come up with for everybody. That's what they are doing [in the picture]. The people are coming. Before, it was there, you could cross. There was no border in the land marking it. You could cross and you know that your land is not Mexico or the United States, but O'odham. They were trying to find out how to keep the life like before.

FIGURE 59. *Call for Unity, Sovereignty, Human Rights, and Indigenous Land Rights*

This was the last design that I did connected to that one of the split rock (fig. 60). Here it is. It's mainly the people that stood up to be leaders. This guy had taken over. He was doing other things, just for himself, going and using the money for something else. So an Elder, Asencio Antone, the guy from Pozo Verde, took over the more traditional group of Elders, and that's when they asked him to do this [meeting]. It wasn't the Treaty Council. When Asencio died, his son took over. They are the people that I see now and then. They were com-

ing together again; I think it was for a blessing. They had some medicine people. One of them was that lady from Big Fields. I put her in the picture, and Asencio, the guy from Pozo Verde. Him and his son took over. They were doing more traditional. The Treaty Council guys were still around, showing the papers, and the weapons in the background. They're [the Treaty Council people] more out-spoken and doing more things with their emotions. The Elders are more quieter and they get their message across with the medicine men and the singing.

The Elders would invite other people to come. One time a story-teller told about the creation that went throughout the land. When they talk about creation, it's every-where, the mountains in Arizona, different areas, and wherever the O'odham live. In their stories, the people tell how things came to be, more traditional stuff. They say that gives you the strength to do other things, as long as you know your background and how the people from long ago used to talk about it. It gives you the strength, I guess, just to be O'odham. Where you came from; where you belong; what to do to protect yourself, protect the land. They asked me if they could make a poster, print some, to give to the people that took part in it.

FIGURE 60. *Unity/Sovereignty*

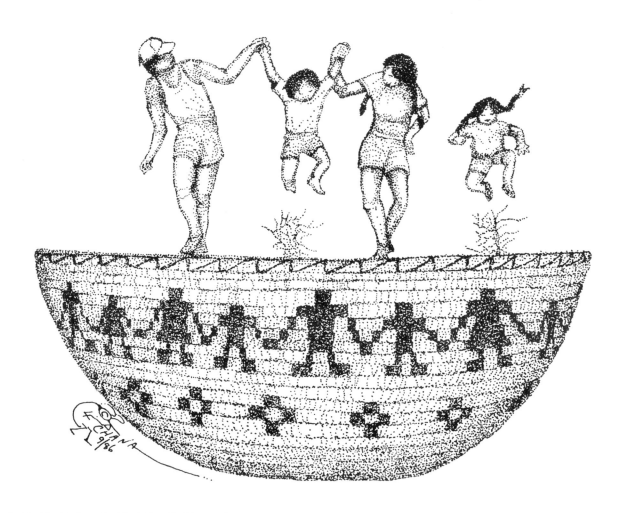

FIGURE 61. *Healthy Mothers, Healthy Babies, Healthy Families*

They Were Looking for an Artist

Most of the posters then [mid-'80s] were for the tribal Health Department in Sells. My friend worked there and she always asked if I could do a design for them. So I did quite a bit with them guys and then with other people that would come and ask.

This one shows taking care of family: *Healthy Mothers, Healthy Babies, Healthy Families* (fig. 61). They use it a lot in the Health Department. I did that for one of their brochures. Then they keep coming back and asking me to use it, so I keep charging them. [laughing] So I said, "Why don't you just buy it; then you don't have to pay for it, because every time I have to charge you for it." So they finally bought it. But they have all kinds of stuff: T-shirts, cups with this design. I see a lot of it now and then.

The group [Kinship Adoption Resource Education (KARE) Family Center] is working with kids that are being adopted—whether they should be adopted to anybody who wants to adopt a child. They were saying that it is best to try to return them back to the family, if anybody in the family would like to take them under their wing and take care of them. They prefer that than adopting them to other people. I knew that, since I feel that way, when you are torn apart from your family, nothing really belongs to you. You are just out there and wherever you are, you are on it temporarily. You don't own anything, just what you carry in your bag or your suitcase. That's all that belongs to them, really. The same way with the grandmother or the grandparent. There is no other

SUSAN LOBO: In this chapter Leonard speaks of some of the many ways he created community-focused art for the Tohono O'odham and other Native projects and organizations.

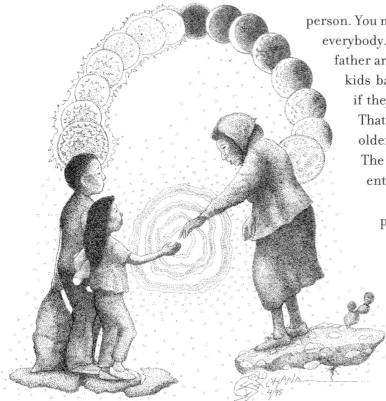

FIGURE 62. *Completing the Circle of Life*

person. You may have the land, but you still feel alone, apart from everybody. So if your family is all torn up—the mother or the father are not there and won't take any initiative to get their kids back—so it's usually the grandparents who end up, if they are able, getting the kids, raising them (fig. 62). That's why I put the sun and the moon . . . as you get older, it becomes the moon, but if you are able, the sun. The tribe prefers [children] to be given back to the parents [or relatives], the O'odham.

It's like you [the grandparent] feels alone on a piece of property where you are from, and that one [in the picture] has the cactus. For her, that's security because she's got that land. But for them [the kids], it's broken up and that's how their lives are. That piece of land that's all broken up is not yours, and they don't feel secure because of this little ground. No telling which way it's going to go. You find somebody who actually reaches out to you, to help you. If you are the grandmother you can already feel the energy, the connection. But once they get in with her even though it's not as secure, they feel the love and the care. But they still don't feel they belong until they make sure and wait and see what happens.

That's what the group [KARE] wanted to get across, that they should be adopted back or given back to the family. I knew different kids, when they were growing up, how nobody really was there to take care of them. They must feel out of place, like nobody cares. They just disappeared [out of the community and went into the social service system], until they are old enough to be on their own. Then somebody would see them again. How sad it was for them not to know what I felt [growing up] because of living with my parents.

People [who were adopted out] coming back and looking for their roots and stuff—I got a lot of that when I used to set up [to sell] at San Xavier [Mission]. People would show up and then they'd start asking questions. They'll say they were adopted and now, "I'm trying to get in touch with my family." And they say, "Do you know anything about Apaches or Pimas?" or "Where can I go to find out more about where I come from?" A lot of them would come back [after making contact with their birth family or community], and they say, "Well, I wasn't

really accepted because I didn't know [the culture] . . ." But they start their own life out here, however they can. Others are just satisfied to know where they come from. If they don't know who their parents or who their relatives are, they are just satisfied knowing where they belong, even though they are not accepted. They stay around and they

FIGURE 63. Theresa Griffin. Leonard Chana painting Caroline Antone's face in preparation for domestic violence prevention poster (fig. 64)

FIGURE 64. Domestic violence prevention poster

feel more close, but not that close. I saw a lot of that, people coming back and looking for their roots and stuff.

You know, they would talk about how [in foster care] when they turned eighteen, they kicked them out. "It's time for you to go." This one girl was saying she was O.K. up until [foster care ended]. They never taught her anything about her tribe or whatever, "But I went to the library and I read about them, but it didn't give me the fullness of what I needed to find out." She was Apache. She still looked for anybody who was related or would even know her. So she said, "I just decided I needed to do what I needed to do, and go on with my life." I see her now and then. She got married and is raising kids, got into the Christian music, and she was saying they sing and go out to the different shows.

This one was for the National Congress of American Indians '89 or something like that (fig. 65). A friend, Tony Felix, said, "You should send that picture in," because they were having a contest. They were looking for an artist to send in work. He was saying, "Yeah, they should, because the O'odham never do anything like that." I just kind of laughed at him. You know, I'd never done it. Then I went to see another friend, Mark Ulmer, one night and he said the same thing, "You should send your name in, or send something in so they can pick it." Then he said, "Tell them I'm your lawyer or something like that." And I kind of just laughed it off and finally I said, "Well, I'll try it out." So I did that one. I wasn't really sure what to do, but "the eagle represents that we will need to go beyond survival. The lightning depicts the barriers we put up within ourselves. The sacred pipe and maze of life signify the cultural strength within our hearts and minds." That's what I wrote when I sent it in. I guess there was a poster or something with that written at the bottom.

Then Felix came by and asked me about it. And I told him, "Yeah, I did." And he was happy about it. Then when they let me know they were going to use it, it was a surprise for me. I never thought they would. When they picked it out, they asked me to come to Phoenix and pick up my reward. I don't remember if they gave me money or what. $50 or something. I don't know. Maybe $25. But that kind of got me to start doing more posters and stuff for people that asked.

They never sent the original back to me. I think this guy that was doing this at the time kept it. I called him, trying to get it back from him, but he said, "Yeah, I'll go look for it." But I never got it, and one

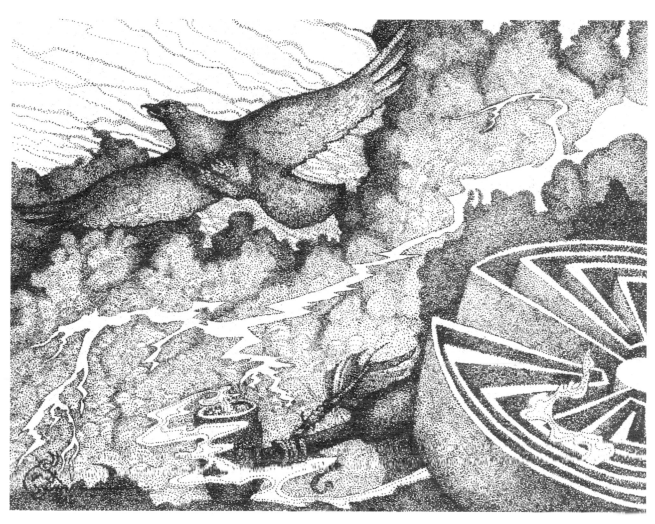

FIGURE 65. *Beyond Survival:*
The Next Step Is Ours

time I found him in one of the offices over by Firebird Lake. He said, "Oh, I remember you. I'll send it to you when I find it." So he's got it somewhere . . . in his house probably.

That was my first one for such a large group, and for people that I don't know. I remember how long it took me and I always felt uneasy about it. That was my first print, actually, on a poster that went out nationally and had something to do with the O'odham people.

They were doing a conference in Georgia and it was for the Indian in America. A guy asked somebody from the Indian Center if they could find an artist to do a design for them (fig. 66). Barbara [my wife] picked it up. They told what they wanted and she asked me if I could do it. So she told me what it was for.

I never saw what the conference was. It was kind of a mystery what

FIGURE 66. *Consultation in Process*, National Indian Leaders' I.H.S. Policy Meeting

they were trying to do. Maybe something they took from their life and having to rebuild it again. I guess they are putting it back together to complete something others took from them. They took it out . . . or else they are putting it back inside. [laughing] I think maybe they were putting it in there. So I put the hands putting the pieces back. Anyway, that's why I did the piece.

They said, "We need it in a couple of weeks." So I tried to do it simpler. That was probably during the time that I was trying to do all dots, because it looks like they are all dots. There are no lines.

They took the original and they probably kept it. It was kind of a mystery once it left my hands, until I got this poster. I had some posters that burned. Our house [at Santa Rosa] burned back in '95. My stuff burned: my diplomas from Pima College, from grade school, and old photos.

A tribal representative, Virgil Lewis, called me one time. He was the representative of his district. Virgil said, "I want a design that means the O'odham people. Whatever you can come up with." What I did here was the family together, which is power, and the connection to the eleven tribal districts (fig. 67). And then the unborn are coming up to keep our traditions and pass it on. We keep it strong all the time. We are strong people with our traditions. Whatever we do, we keep our families together and we learn from each other, just like when we lived

in one room, knowing everything your family does. The original is in the White House, where the chairman is, the tribal administrative center at Sells.

The Sand Papagos are back [near] Ajo [a town just west of the reservation]. They didn't have any land. It was already taken over, so they went to [work in] the mine. I used to hear them say the "Hia-Ced O'odham" [Sand Papago], and I didn't know who they were. My dad would say, "Oh, over there near Mexico, but on the Arizona side." But I had never seen them until I came to Tucson, after going to boarding school. Then I found out they were Sand Papagos. Their language is pretty much like the Pimas. There are certain words that are different. When I first met some I was in Magdalena [Mexico]. Everybody goes there [for the fiesta of St. Francis].

The O'odham [living in Mexico] dress like the Mexicans, Western. When you talk to them, they talk real fast. I guess the Mexican language [speed] is how they talk. At first I thought they were trying to talk to me in Spanish because I couldn't understand. It was too fast. Then I'd have to say, "What?" That's another thing, you are supposed to respect and not keep asking. But I kept saying, "What?" At first I didn't ask them, but later I wanted to find out what they were talking about and they would repeat it. Then I could get words, O'odham words here and there. That's when I found out that O'odham people also lived in Mexico.

FIGURE 67. *Ahchim O'odham (We the People)*

The Hia-Ced O'odham have an office in Sells and they wanted a logo (fig. 68). Before they had a circle and a bow and arrow, but they wanted an eagle. So I was trying to ask them, "Where do you want the eagle?" They didn't know. They said, "Use your expertise." [laughing] So I did that. I'm not sure what they use the circle for or even the bow and arrow. They just gave me the old piece to use. It was kind of simple. I made it more so that people can look at it and see the detail. It was '93 or '94, around there. The coming year they had the rodeo and [they had a booth there]. They put all their stuff on the wall, and they put the original logo up. Somebody came by and lifted it. [laughing] I said, "Why did you put the original up? Why didn't you put a copy up there?" They said, "I don't know."

FIGURE 68. *Hia'ced O'odham Logo*

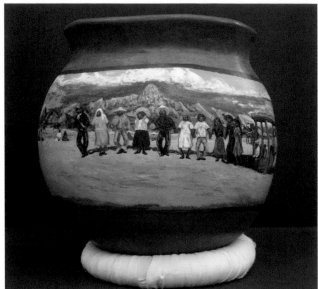

FIGURE 69. Untitled

TOHONO O'ODHAM

BASKETWEAVERS
ORGANIZATION

FIGURE 70. Untitled

[To make the pottery] they build them up in layers and they add to them (fig. 69). The bottom part they do it like this [paddle and anvil]. Alicia's [Bustamonte] mother did big ones but her [Alicia's] hands have been hurting so she's been doing the little ones. Alicia said, "I could do another big one, but I never take the time to finish it." When I painted it I had it on a lazy Susan and turned it. I put gesso there first, then colors. It's just like a painting. She wanted a desert scene. I'd do the bottom, the dirt, and then put all the stuff on top.

This is an old one, but you can see how I used to carve the handles (fig. 71). You can see the maze. I did that on a lot of them. There was a painted gourd that was bigger, but when someone broke into my sister's house, I had them on the bed and they stepped on it, coming in through the window. [laughing] The other one that is back there is broken too, so I have to put it together and paint over it again.

I did one for this guy, a Vietnam vet (fig. 72). When he came back he was really off balance. So he ended up working for this ranch where they had horses. The horses calmed him down, so he asked me to do a picture with the horses. I put what he did in the war. He was a radio man. I guess he went through a lot, but that's what I put in the sky. He was telling me that he was over there when the man first walked on the moon, and that's the one off to the right. The radio man is on the left side of the clouds there. The horses helped him, to soothe him from that post-traumatic stress. The wolves couldn't get them because the

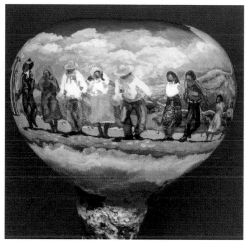

FIGURE 71. Untitled

horses are too big. The little one is being protected also. It shows the new view and not always being stressed out. It shows his newfound way to get rid of those demons and bad dreams of whatever happened to him, and whatever he saw over there.

It took me a while because I was really trying to think of what he told me and how I wanted to put it. I knew the horses were going to be there and that's what I started with, but the rest of it, I couldn't see until once I started putting everything in the background. The clouds were the last ones, so that's what all came together finally.

FIGURE 72. Untitled

It came out pretty nice. He told me he really enjoyed it. When I finished the picture, I had it in the house and a lot of people come by and saw it. They liked it and they always asked me, "Are you going to make a print of it?" I told them: "I don't know, I haven't seen him yet. Once I see him, I'll ask him." So when they came to pick it up, I asked him and he said, "Yeah, go ahead." And right away, "Make some or whatever you want to do." It came out real nice.

I did this one for my niece because she was teaching traditions and culture at a preschool (fig. 73). She is dressing them up for a dance performance. I put the maze in there because it was Tohono O'odham. They say when you are really, really doing the real traditional thing, the men are the ones who are taking care of the boys and getting them ready, and the women are the ones taking care of the girls. But now in the preschool, they do a performance and all the women, they help them to prepare. When they did the inauguration for the new chairwoman, they had all the little kids in there. They had the dancers and the clouds and the birds. You can't confine it [teaching the tradition] to one place. You have to do it everywhere, not just one place. Teaching is like culture, it starts at home with parents, relatives, and friends.

FIGURE 73. *The Teacher*

FIGURE 74. *Catch Up*

References

Baylor, Byrd

1991 *Yes Is Better than No.* Tucson, Ariz.: Treasure Chest Publications.

1997 *The Way to Make Perfect Mountains: Native American Legends of Sacred Mountains* El Paso, Tex.. Cinco Puntos Press.

Nabhan, Gary

2002 *Enduring Seeds: Native American Agriculture and Wild Plant Conservation*. Tucson: University of Arizona Press.

Saxton, Dean, and Lucille Saxton

1969 *Papago & Pima to English, O'odham–Mil-gahn; English to Papago & Pima, Mil-gahn–O'odham Dictionary*. Tucson: University of Arizona Press.

Saxton, Dean, Lucille Saxton, and Susie Enos

1999 *Tohono O'odham/Pima to English, English to Tohono O'odham/Pima Dictionary*. 2nd ed. Tucson: University of Arizona Press.

This list of illustrations includes all information known at the time of publication. Any corrections or additions would be appreciated for future editions. The public may see Leonard Chana's artwork at the Tohono O'Odham Nation Cultural Center and Museum (fig. 34, *Waila Dreams*) and at the Archie Hendricks Skilled Nursing Facility (fig. 22, dance mural).

<div align="right">— Barbara Chana and Susan Lobo</div>

Introductory Material

1. Ross Humphrey, "Leonard F. Chana at work in his home," 1993, black and white photograph.

2. Leonard F. Chana, *Art*, 1989, pen and ink, 4 in. x 5 in. Courtesy of Barbara Chana.

Chapter 1. Mom and Dad: That's How They Got Married

3. Unknown, "My parents' wedding," April 1, 1934, black and white photograph. Chana family collection.

4. Leonard F. Chana, *Sharing the Excitement*, 1996, pen and ink, 3 in. x 5 in. Courtesy of Barbara Chana.

Chapter 2. When I Was Little

5. Leonard F. Chana, *Youth: Endless Time*, 1990, acrylic on canvas, 13.25 in. x 11.25 in. Courtesy of Anthony and Ana Chana. (photograph of artwork by Carol Charnley, the Amerind Foundation, Dragoon, Arizona)

6. Leonard F. Chana, Untitled (basketweaver), 2002, acrylic on canvas, 8 in. x 6 in. Saguaro-rib frame by Al Peyron. Courtesy of Rick Miller. (photo-

graph of artwork by Carol Charnley, the Amerind Foundation, Dragoon, Arizona.)

7. Leonard F. Chana, Untitled (family eating under the ramada), 1988, pen and ink, 11 in. x 18 in. Courtesy of Barbara Chana.

8. Leonard F. Chana, *Waila, the Chicken Scratch*, 1988, pen and ink, 13 in. x 5 in. Courtesy of Barbara Chana.

9. Leonard F. Chana, Untitled (fiddler and guitar player), 1996, pen and ink, 3 in. x 5 in. Courtesy of Barbara Chana. (photograph of artwork by Carol Charnley, the Amerind Foundation, Dragoon, Arizona)

10. Leonard F. Chana, *High Noon*, 1995, pen and ink, 35.75 in. x 35.75 in. Courtesy of Bernard and Regina Siquieros. (photograph of artwork by Anya Monteil, Tohono O'odham Nation Cultural Center and Museum, Topawa, Arizona)

11. Leonard F. Chana, *Toka*, 1994, pen and ink, 11 in. x 18 in. Courtesy of Barbara Chana. (photograph of artwork by Carol Charnley, the Amerind Foundation, Dragoon, Arizona)

12. Unknown, Untitled (playing *toka*), 1940, black and white photograph. Courtesy of the Arizona Historical Society.

13. Leonard F. Chana, *Carrying Water for Mom and Aunt Molly*, 1999, acrylic on canvas, 24 in. x 18 in. Courtesy of David Waine. (photograph of artwork by Carol Charnley, the Amerind Foundation, Dragoon, Arizona)

14. Leonard F. Chana. *Olla Beating Game*, early 1990s, pen and ink, 11 in. x 16 in. Courtesy of Barbara Chana.

15. Leonard F. Chana, *Buddies Forever*, 1995, pen and ink, 11 in. x 18 in. Courtesy of Barbara Chana. (photograph of artwork by Carol Charnley, the Amerind Foundation, Dragoon, Arizona)

Chapter 3. I'itoi: He Is the One Who Taught the O'odham

16. Leonard F. Chana, *Purification*, 1988, pen and ink, 11 in. x 15 in. Courtesy of Barbara Chana.

17. Leonard F. Chana, *The Blessing*, 1988, pen and ink, 18 in. x 11 in. Courtesy of Keith Kleber. (photograph of artwork by Anya Monteil, Tohono O'odham Nation Cultural Center and Museum, Topawa, Arizona)

18. Leonard F. Chana, Untitled (dancers), 1988, pen and ink, 11.75 in. x 8.5 in. Courtesy of Barbara Chana.

19. Leonard F. Chana, Untitled (saguaro fruit harvest), 2004 (unfinished), acrylic on canvas, 30 in. x 14.5 in. Courtesy of Jason Aberbach. (photograph of artwork by Anya Monteil, Tohono O'odham Nation Cultural Center and Museum, Topawa, Arizona)

20. Leonard F. Chana, Untitled (taking a break), 1994, acrylic on canvas, 16 in. x 20 in. Saguaro-rib frame by Donny Preston. Courtesy of Donny Pres-

ton. (photograph of artwork by Anya Monteil, Tohono O'odham Nation Cultural Center and Museum, Topawa, Arizona)

21. Leonard F. Chana, Untitled (preparing saguaro fruit syrup), 1981, acrylic on canvas, scene size 24 in. x 36 in., a portion of a mural that measures 7 ft. x 5 ft. Courtesy of Barbara Chana. (photograph of artwork by Carol Charnley, the Amerind Foundation, Dragoon, Arizona)

22. Leonard F. Chana, Untitled (dance scene), 2001, mural, acrylic on canvas, 110 in. x 16 in. Courtesy of Archie Hendricks Skilled Nursing Facility, Tohono O'odham Nation. (photograph of artwork by Cody Chavez)

23. Unknown, Untitled (overview of ceremonial gathering at Santa Rosa village), early 1940s, black and white photograph, 4.5 in. x 2.75 in. Courtesy of Marie R. Chana photographic collection.

24. Unknown, Untitled (man with basket at ceremonial gathering at Santa Rosa village), early 1940s, black and white photograph, 7.2 in. x 4.2 in. Marie R. Chana photographic collection.

25. Leonard F. Chana, Untitled (man with basket), late 1990s, pen and ink, 20 in. x 18 in. Courtesy of Barbara Chana.

26. Leonard F. Chana, *Light of the World*, 1994, pen and ink, 16 in. x 22 in. Courtesy of Barbara Chana.

Chapter 4. Because I Can Feel It

27. Leonard F. Chana, *The Way to Make Perfect Mountains*, 1996, acrylic on canvas, 12 in. x 24 in. Saguaro-rib frame by Donny Preston. Courtesy of Jason Aberback. (photograph of artwork by Carol Charnley, the Amerind Foundation, Dragoon, Arizona)

28. Leonard F. Chana, Untitled (painted gourd rattle), 1996, acrylic on gourd, approximately 10 in. x 6 in. Courtesy of Bernard and Regina Siquieros. (photograph of artwork by Anya Monteil, Tohono O'odham Community Center and Museum, Topawa, Arizona)

29. Leonard F. Chana, *Young Medicine Man, Hegal Wechlj Oodham Mod Mah Jal*, 1987, pen and ink, 8 in. x 10 in. Courtesy of Craig Encinas.

30. Leonard F. Chana, Untitled (snake and eagle), 1989, pen and ink, 9.5 in. x 11.75 in. Courtesy of Barbara Chana.

Chapter 5. Some of the Things She Wrote about I Remember

31. Leonard F. Chana, *Sweet Smell of Home on My Mind*, 1990, acrylic on canvas, 20 in. x 16 in. Courtesy of Barbara Chana.

32. Leonard F. Chana, *Yes Is Better than No*, 1990, acrylic on canvas, 20 in. x 16 in. Courtesy of Barbara Chana.

33. Unknown, Untitled (waila dance at Santa Rosa), late 1940s, black and white photograph, 2 in. x 3 in. Marie R. Chana photographic collection.

34. Leonard F. Chana, *Waila Dreams*, 1998, acrylic on canvas, 20 in. x 16 in. Courtesy of Susan Lobo.

35. Leonard F. Chana, Untitled (woman making tortillas), 1990s, acrylic painted on pottery plate, 12 in. diameter. Pottery created by Alicia Busta-monte. (photograph of artwork by Donny Preston)

Chapter 6. Sherman

36. Leonard F. Chana, Untitled (parents and youth), 1993, pen and ink, 12.5 in. x 11 in. Courtesy of Barbara Chana.

37. Leonard F. Chana, Untitled (woman and burden basket), 1998, pen and ink, 3.5 in. x 5.5 in. Courtesy of Barbara Chana.

Chapter 7. Working with My Dad

38. Leonard F. Chana, Untitled (selling produce from wagon under tree), 2000, acrylic on canvas, 22 in. x 28 in. Courtesy of Ted Townsend.

39. Leonard F. Chana, *Memory of the Music*, 1999, acrylic on canvas, 20 in. x 10 in. Courtesy of Barbara Chana.

40. Leonard F. Chana, Untitled (slow-release foods booklet), 1990, pen and ink, 8.5 in. x 5 in. Courtesy of Native Seeds/SEARCH.

41. Leonard F. Chana, Untitled (eating watermelon), 1992, acrylic on canvas, 13.5 in. x 18 in. Courtesy of Elisabeth Roche. (photograph of artwork by Anya Monteil, Tohono O'odham Nation Cultural Center and Museum, Topawa, Arizona)

42. Leonard F. Chana, *My Dad, Louis Chana*, 1999, pencil on paper, 16 in. x 22 in. Courtesy of Barbara Chana.

Chapter 8. They Really Raised Havoc

43. Leonard F. Chana, Untitled (booze and doll), 1988, pen and ink, 11 in. x 17 in. Courtesy of Barbara Chana.

44. Leonard F. Chana, Untitled (steer rider), 1996, pen and ink, 11 in. x 17 in. Courtesy of Barbara Chana.

45. Leonard F. Chana, *Wild Bill*, date unknown, pen and ink, 12 in. x 17 in. Courtesy of Barbara Chana.

46. Leonard F. Chana, *Mr. Calm*, 1992, pen and ink, 11 in. x 17 in. Courtesy of Barbara Chana.

Chapter 9. So I Was Tired of Drinking Anyway

47. Leonard F. Chana, Untitled (farming), 1982, acrylic on canvas, 20 in. x 16 in. Courtesy of Native Seeds/SEARCH, Tucson, Arizona.

48. Leonard F. Chana, Untitled (Christmas card), 1978, pen and ink, 5 in. x 5 in. Courtesy of Barbara Chana.

49. Leonard F. Chana, Set of basket and animal cards, 5 in. x 5 in. Courtesy of Barbara Chana. (*a*) Hohokmal (butterfly), 1991; (*b*) Rattlesnake, 1986; (*c*) Ba'ag (eagle), 1991; (*d*) Huawi (mule deer), 1991; (*e*) Chuk Ud (owl), 1986; (*f*) Nakshel (scorpion), 1991; (*g*) Kumkch'd (tortoise), 1991; (*h*) Ban Gohki (coyote tracks), 1985.

50. Leonard F. Chana, Untitled (woman combing her hair under ramada), 1983, pen and ink, 14 in. x 11 in. Courtesy of Barbara Chana.

Chapter 10. The Courage to Change: My Life Is Open

51. Leonard F. Chana, *There Is a Solution*, 1983, pen and ink, 13 in. x 12 in. Courtesy of Barbara Chana.

52. Leonard F. Chana, *In the Fight for Life and Death*, 1991, pen and ink, 33 in. x 14 in. Courtesy of Barbara Chana.

53. Leonard F. Chana, *Courage to Change*, 1990, pen and ink, 11 in. x 14 in. Courtesy of Barbara Chana.

54. Leonard F. Chana, *Carrying the Message*, 1989, pen and ink, 9 in. x 9 in. Courtesy of Barbara Chana.

Chapter 11. The Maze Broken in Half

55. Leonard F. Chana, Untitled (north and south facing one another), 1981, pen and ink, 17 in. x 11 in. Courtesy of Barbara Chana.

56. Leonard F. Chana, *The Reunion*, 1983, pen and ink, 12 in. x 17 in. Courtesy of Barbara Chana.

57. Leonard F. Chana, Untitled (flier for Jim Thorpe Longest Run), 1984, pen and ink, 8.5 in. x 11 in. Courtesy of Barbara Chana.

58. Leonard F. Chana, Untitled (killing in Ajo), 1983, pen and ink, 11 in. x 17 in. Courtesy of Barbara Chana.

59. Leonard F. Chana, *Call for Unity, Sovereignty, Human Rights, and Indigenous Land Rights*, 1989, pen and ink, 11 in. x 14 in. Courtesy of Barbara Chana.

60. Leonard F. Chana, *Unity/Sovereignty*, 1994, pen and ink, 11 in. x 14 in. Courtesy of Barbara Chana.

Chapter 12. They Were Looking for an Artist

61. Leonard F. Chana, *Healthy Mothers, Healthy Babies, Healthy Families*, 1986, pen and ink, 7.25 in. x 10.25 in. Courtesy of Community Health Department, Tohono O'odham Nation.

62. Leonard F. Chana, *Completing the Circle of Life*, 1995, pen and ink, 17 in. x 11 in. Courtesy of Barbara Chana.

63. Theresa Griffin, Untitled (Leonard painting Caroline F. Antone's face), 2000, black and white photograph.

64. Leonard F. Chana, Untitled (domestic violence prevention poster), 2002, 11 in. x 17 in. Designed by Caroline F. Antone. (photograph of artwork by Theresa Griffin)

65. Leonard F. Chana, *Beyond Survival: The Next Step Is Ours*, 1986, pen and ink, 12 in. x 17 in. Courtesy of Barbara Chana.

66. Leonard F. Chana, *Consultation in Process*, National Indian Leaders' I.H.S. Policy Meeting, 1988, pen and ink, 11 in. x 17 in. Courtesy of Barbara Chana.

67. Leonard F. Chana, *Ahchim O'odham (We the People)*, 1990, pen and ink, 11 in. x 17 in. Courtesy of Barbara Chana.

68. Leonard F. Chana, *Hia'ced O'odham Logo*, 1990s, pen and ink, dimensions unknown. Courtesy of Barbara Chana.

69. Leonard F. Chana, Untitled (dance scene), 1990s, acrylic on pottery, 1990s, diameter of pottery 15 in. Pottery created by Alicia Bustamonte. Courtesy of Terrol Dew Johnson. (photograph of artwork by Anya Monteil, Tohono O'odham Nation Cultural Center and Museum, Topawa, Arizona)

70. Leonard F. Chana, Untitled (Tohono O'odham Basketweavers Organization logo), 1999, pen and ink, 18 in. x 20 in. Courtesy of Tohono O'odham Community Action.

71. Leonard F. Chana, Untitled (round dance), 1985, acrylic on gourd rattle, 11 in. x 5.25 in. Courtesy of Ida Norris and family. (photograph of artwork by Anya Monteil, Tohono O'odham Nation Cultural Center and Museum, Topawa, Arizona)

72. Leonard F. Chana, Untitled (horses and clouds), 1994, acrylic on canvas, 22 in. x 28 in. Courtesy of Barbara Chana.

73. Leonard F. Chana, *The Teacher*, 1993, pen and ink, 12 in. x 14 in. Courtesy of Barbara Chana.

74. Leonard F. Chana, *Catch Up*, 1993, acrylic on canvas, 9 in. x 12 in. Courtesy of David Waine, Indigenous Fine Art Publishers, Ltd.

75. Al Peyron, "Leonard and his saguaro friend," summer 2002.

FIGURE 75. Al Peyron, "Leonard and his saguaro friend"

About the Authors

Leonard F. Chana was born in October 1950 in Arizona on the Tohono O'odham reservation, in the village of Kiej Mek, now called Santa Rosa. Educated at Bureau of Indian Affairs boarding schools and Sherman Indian High School in Riverside, California, he received no formal art education. He attended Pima Community College in Tucson, Arizona, where he received a degree in social service. A self-taught artist, his work became noticed when he began to illustrate his learning experiences of the O'odham way of life. While alive he never had a formal showing of his art, in particular because his work sold before he could show. He illustrated for several publications featuring O'odham lifestyle or Sonoran Desert life. His early work was in pen and ink, stippling. His later acrylic paintings often featured the harvesting of saguaro cactus fruit and the *waila* festivals, a contemporary dance of the O'odham. His art conveyed both depth and meticulous detail. Leonard passed away in January 2004.

Susan Lobo is trained as a cultural anthropologist and works as a consultant, emphasizing research, advocacy, and project design and evaluation. She works primarily for American Indian tribes and community organizations in the United States and Latin America. Between 1978 and 1995 she was the coordinator of the Community History Project located at Intertribal Friendship House in Oakland. She has taught at the University of California at Berkeley and at Davis, as well as at the University of Arizona, where she is currently a visiting scholar. She is also now working with Tohono O'odham Community Action (TOCA) as a consultant. Her publications include *A House*

135

of My Own: Social Organization in the Squatter Settlements of Lima, Peru, Native American Voices: A Reader, American Indians and the Urban Experience, and *Urban Voices: The Bay Area American Indian Community.* She has also published numerous articles in the *American Indian Culture and Research Journal, Native Peoples, American Indian Quarterly, MesoAmerica, News from Native California,* and many others.

Barbara Chana (Tohono O'odham/Akimel O'odham) was raised in a small O'odham community within Barrio Libre in urban Tucson, Arizona. Barbara and Leonard met in the mid-1970s while working for an Indian education program, were married for twenty-three years, and had one daughter. A licensed substance abuse therapist, the majority of her work has been with tribal people. A frequent presenter about the dynamics of Native families and substance abuse, she utilizes her husband's art as a way of increasing knowledge and conveying recovery and hope. She values her eclectic education but honors the foundation centered and rooted in the O'odham way of learning. As a steward of Leonard's art, she purposes to keep his message simple but meaningful, much in the way he presented himself.

Angelo Joaquin Jr. is a member of the Tohono O'odham Nation. He has been the cultural liaison, and was the co-founder, of the Tucson Waila Festival. He is a documenter of the waila tradition and its musicians. He is pursuing a degree in ethnomusicology at The University of Arizona and is the coordinator of the Arizona State Museum's Southwest Indian Art Fair. He was a two-term member of the International North American Folk Music and Dance Alliance and a past executive director of Native Seeds/SEARCH. He has served as a visual arts consultant for the Arizona State Museum, the Arizona Historical Society, the Museum of Indian Arts and Culture, the Library of Congress, and the National Museum of the American Indian.

Rebecca J. Dobkins is professor of anthropology and faculty curator of Native American art at Willamette University in Salem, Oregon. Her research focuses on the work of contemporary Native artists in California and the Pacific Northwest. Her publications include the monographs *Joe Feddersen: Vital Signs* (Hallie Ford Museum of Art and University of Washington Press, 2008), *Rick Bartow: My Eye* (Hallie Ford Museum of Art, 2002), and *Memory and Imagination: The Legacy of Maidu Indian Artist Frank Day* (Oakland Museum, 1997).